Amphoto Guide to

Lighting

Amphoto Guide to
Lighting

Lou Jacobs, Jr.

AMPHOTO
American Photographic Book Publishing Co., Inc.
Garden City, New York 11530

Note: In the appendix of this book, you will find a table for converting U.S. Customary measurements to the metric system. You will also find a table for ASA and DIN equivalents.

Library of Congress Cataloging in Publication Data
Jacobs, Lou.
 Amphoto guide to lighting.

 Includes index.
 1. Photography—Lighting. I. Title. II. Title: Guide to lighting.
TR590.J23 778.7 78-21626

ISBN 0-8174-2140-7 (softbound)
ISBN 0-8174-2467-9 (hardbound)

Manufactured in the United States of America

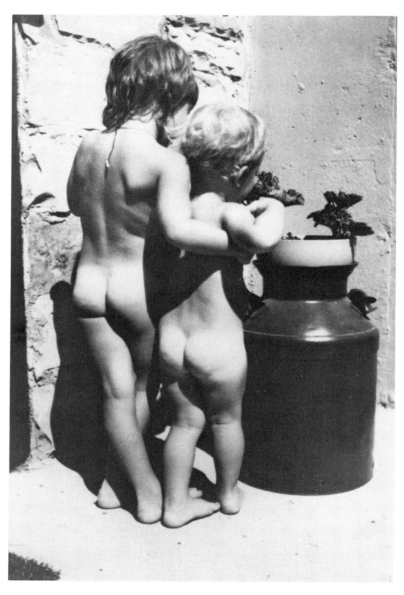

Dennis Omundson made the original photo of this charming twosome on Type 108 Polaroid color film.

Contents

Introduction

The Facts of Light and Lighting

Cameras, lenses, film, and light are all for sale with a variety of price tags, and light is also available free—like the best things in life. Unfortunately, the mere existence of enough light is no assurance you'll get the pictures you imagined, dreamed about, or seriously tried to shoot. Light is a tool we have to learn to use with confidence. It is also one of the keys to mastering the photographic medium.

We need light to take pictures. Often it's there, indoors or out, or we apply it in the form of flash or floodlight, but either way it's easy to take light for granted. We become involved with people and places, and tend to ignore the esthetics—to which light is a primary contributor. When did you last wait ten minutes or half an hour for the light to change on a mountain? Have you ever used an umbrella reflector for portraits? Can you recall pictures that might have been better had you taken more care with lighting?

This book has two main goals: 1) to explain and demonstrate the techniques and facts of lighting, and 2) to make you critically aware of light from artistic and practical viewpoints.

Light *makes* many pictures, which means that the quality of the light creates the distinction between the ordinary and the unusual. As an example, think of the

smooth lighting of a Karsh portrait as compared to the harsh contrast that typifies so many outdoor squinty snapshots.

You are going to experiment in many directions as you read this book, I hope. At the same time you'll be looking at the light in photographs by other people, and you will be more sensitive to mood, atmosphere, and *modeling*, a word that describes what light does to form. Photographers understand that a face or a landscape is more likely to become an exciting image if the light is right. Luckily, there are many paths to "right" light as it affects form and pictorial content. Often the offbeat is more appealing than the obvious.

Perhaps you think that impressive photographs depend on tricks of lighting, but that's not so. You may dramatize highlights and shadows, you may soften or accentuate forms, or you may eliminate detail—all by the way you use light. These are "tricks" covered in this book, but the real trick is in handling light so that viewers are not aware of it—unless you want them to be.

Basic lighting theory doesn't change, it has just become easier to follow theory into practice because of automation, electronics, and other space-age marvels. More than ever, photography is a great means of self-expression. Through the camera's eye you discover visual impact as influenced by light. When you've made plenty of mistakes (as I have), you become more comfortable in photography, and your pictures are more satisfying. You explore new subjects with new ways of light, and tricks become treats.

1

The Pictorial Qualities of Light

Years ago in photography school we joked ironically, "There's no substitute for light," especially when we failed to expose film properly, and our pictures had no shadow detail. We grumbled about malfunctioning shutters or exposure meters in days when built-in camera meters and electronic equipment were unknown. Eventually, we had to admit human error. Our equipment worked fine, but our judgment about light, lighting, and exposure was faulty.

Now we have sophisticated cameras that seem to analyze the light coming through the lens, and "seeing eye" flash units that quench the light to provide "perfect" exposures. But this space-age equipment can cause confusion until you realize that camera meters and thyristor automatic electronic flash units make their sensitive measurements merely as a guide to us. We must still determine whether highlights and shadows in a scene or portrait are suitable. It is always the photographer's option where to point the camera and when to press the shutter release button.

Yes, photography is easier from a technical standpoint, so we need less physical and mental effort and can concentrate on taking pictures. Though there are still

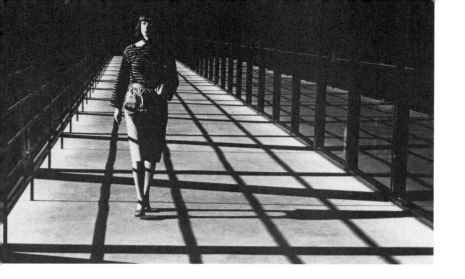

Fig. 1—1. The directional quality of light contributes strongly to the impact of this high-contrast image photographed in mid-afternoon in winter.

camera and gadget lovers, we can be less concerned with hardware, and turn sensitive attention to the *seeing process*, which has always been the nitty-gritty of picture-taking. Think of the many sharp but undistinguished snapshots you've seen, none of which would ever catch the eye of a contest judge. Shutters were snapped at the wrong moment, compositions were careless, facial expressions were grim or ridiculous, and if other elements were okay, the lighting still spoiled the total result. Sometimes we have to take pictures when the sun casts nasty shadows, or with the flat illumination of flash-on-camera. Too little light can cause camera movement at slow shutter speeds, and too much light (arranged by a photographer indoors, for instance) may wipe out form.

Snapshooters are blissfully unaware of these fundamentals. They look for "clear" and "well-centered" images, which is layman talk for nicely exposed, recognizable prints or slides of friends, relatives, or the Grand Canyon. *Enough light is all that matters.*

Aware photographers realize that the *quality* and *direction* of the light influences the appearance of any subject, and may well be responsible for prize-winning pictures. The photographer chooses or creates a certain type of light for mood, for revealing portraits, for fast action, or for quiet still-life arrangements. Each situation may call for a somewhat different lighting treatment. You have to be practical at the same time you're trying to be esthetic, so you make compromises. Most of the material in this book is aimed at helping you juggle practical and esthetic values.

A CHOICE OF LIGHT

The experienced photographer usually gets along well with people, has a good eye for composition and timing, keeps his equipment up-to-date and in good condition, and has learned to generate fairly consistent picture ideas. However, there is always one element not fully predictable: the consistency of light. Wherever you go and whatever you plan, will the sun be high overhead to cause objectionable shadows? Will you be able to find a portrait location with a pleasant background *and* suitable lighting? Will you have to shoot color indoors under a mixture of fluorescent light and

Fig. 1 — 2. Backlighting helped separate the orangutans from their setting in the Los Angeles Zoo.

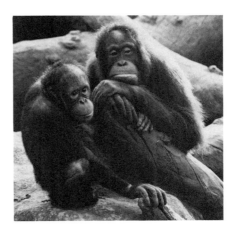

13

daylight—and if so, which is dominant? Will you be able to substitute electronic flash or floodlights for existing light, or is the area too large or the subject inappropriate?

All of these situations will be discussed later in this book. If you're lucky, you will have a choice of light sources and styles. First, you have to determine if the light is bright enough, and whether you have the correct color film to match it. Details in future chapters will help you make these decisions for people, places, and things. When you don't have a choice, you shoot in the light that's there, or you use expedient flash and hope for the best. Let's talk about some specific pictures in terms of light's pictorial qualities, in situations where there may or may not be a choice of lighting.

Fig. 1—1. This opening photograph is symbolic of how strongly light influences visual impact where we shoot. I was visiting a new building for the first time and saw this long passageway divided into geometric sections—which turned me on. However, the expanse was empty and too static, so I asked an attractive girl to walk toward the camera several times to add the human touch the setting needed. Later I printed the negative on high-contrast No. 5 paper to accentuate the strong pattern and forms. The unusual lighting did not require any special exposure, because the scene is rather evenly separated into light and dark segments.

Fig. 1—2. Orangutans are wonderful actors at the zoo—all you need is a telephoto lens and a little patience. It helps if the day is brightly overcast or the sun slants from a form-revealing angle, but if the animals are backlighted when you're there, make the most of it. With an 80–200 mm zoom lens set at 200 mm, I allowed the in-camera meter to average the exposure (explained in Chapter 2), and printed the slightly thin negative on No. 3 paper to hold detail in the orang faces and hands. I might have chosen to return at another time of day when the sun was not

directly behind the orang-actors, but that was not convenient. Besides, they sit with their backs to the sun no matter from which direction it slants.

Fig. 1—3. Photography at night seems a difficult challenge to some people until they experiment with it. Full details are found in Chapter 8, but here let me suggest you get out at night and shoot, because the light often creates dramatic effects. Fast films in color and black-and-white make pictures such as this relatively easy. I rated Tri-X at

Fig. 1—3. The challenge of night photography, in color or black-and-white, can be met with confidence using today's films and cameras.

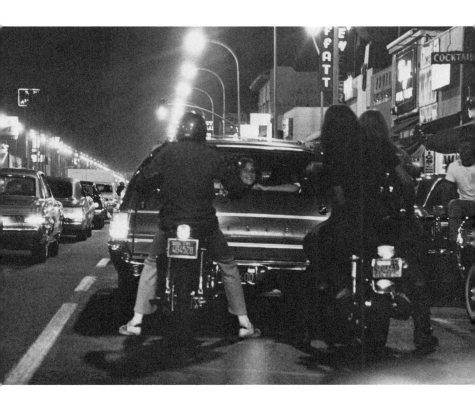

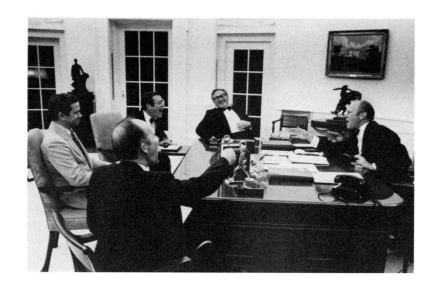

Fig. 1—4. David Hume Kennerly made the most of existing light in the Oval Office on the evening the passing of a news crisis cheered President Ford and staff.

ASA 1000* (developed in Acufine), and was able to shoot at 1/30 sec. and *f*/6.3 with a 35 mm lens on my SLR camera pointed through the windshield of my car. Though bright lights are included in the picture, illumination is distributed evenly enough to provide effective shadow detail. Try street photography at night using Tri-X, Ilford HP5, Ektachrome 400, Kodacolor 400 or Fujicolor with the same rating. Color shots at night have a special impact that sometimes surpasses black-and-white.

Fig. 1—4. Later I will elaborate on my opinion that too often we turn to flash when existing light is not only adequate but offers more atmosphere and authenticity besides. This can be said for David Hume Kennerly's

*See chart, *ASA and DIN Film Speeds*, p. 189.

Fig. 1 — 5. The fine textures of rock in Bryce Canyon are handsomely illuminated by late afternoon sunlight. A 4″ × 5″ view camera amplified detail.

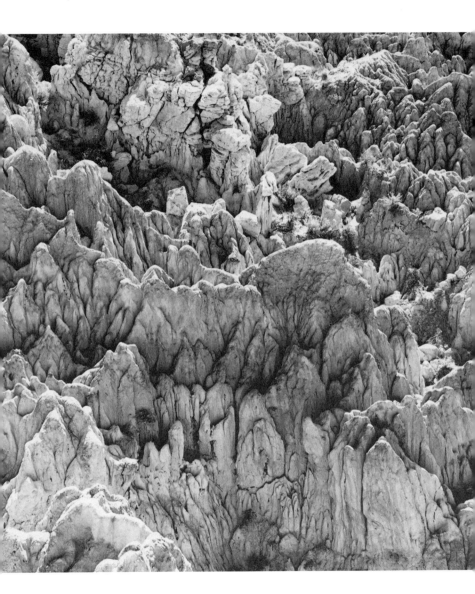

photograph of former President Ford in the White House Oval Office during a meeting that included then Secretary of State Henry Kissinger (center rear). I don't have precise data, but my guess is that room light allowed Kennerly to shoot at 1/125 sec. with a fast film such as Tri-X, rated perhaps at ASA 1200* and processed in a high-energy developer. The light is even and realistic, making the situation more believable. The photograph has lasting interest because of the people in it and their spontaneous emotions as then President Ford was informed that the crew of the captured ship *Mayaguez* had been released by the North Koreans.

In the way Kennerly here exploited existing light to concentrate on picture content, you can photograph the people and events in your life. In the White House scene, light does not offer an esthetic element—in fact, the image might have been more exciting had the light been more directional. But you can see the essentials of expression and the setting clearly, and you know that additional lighting would have been an intrusion. Many family situations you photograph in available light will present parallel circumstances.

Fig. 1—5. Bryce Canyon, backlighted, is a strong example of how light *can* contribute to pictorial distinction. Backlighting—when the light source is directed almost into the lens—is a category you'll hear more about. People and places are usually glamorized by backlighting because it accentuates form along the edges while the rest of the subject seems to glow. Backlighting can also create an air of mystery where detail is obscured in shadow.

PHOTOGRAPHERS' OPTIONS

In general, here are the options we have in terms of lighting:

1. Outdoors in bright sun or in shade, on overcast days, or even when it's raining, there is usually enough light

*See chart, *ASA and DIN Film Speeds*, p. 189.

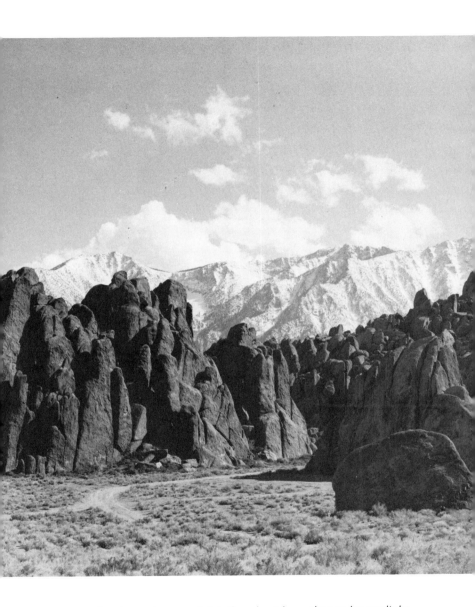

Fig. 1—6. Outdoors, form and detail are best brought out by sunlight
from an angle; photographed by direct sunlight or on an overcast day,
these rocks might look flat.

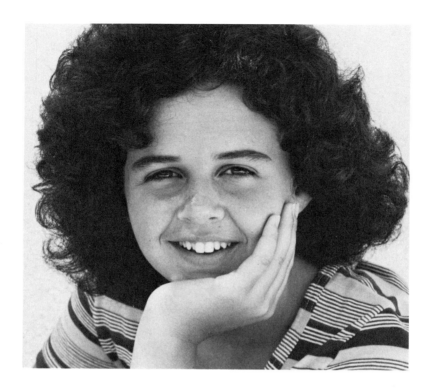

Fig. 1 — 7. Reflected light on the author's patio is soft and flattering, and comfortable on the model, photographed with a 65-135 mm zoom lens on an SLR camera.

to take pictures, and it's often beautiful light as well. That means the light may help to make your subject visually appealing in brilliant or pastel hues.

If it's raining in the Swiss Alps or the Rocky Mountains, and there's no brilliant sun to cast shadows and outline dramatic forms, it's the "wrong" light. But as seen in Fig. 1—5 and now in Fig. 1—6, those craggy rocks with the

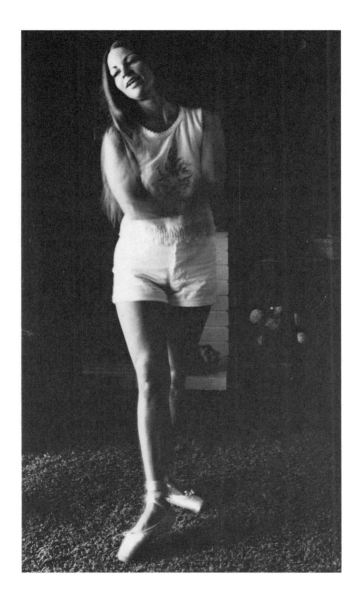

Fig. 1 — 8. Sidelighting from a glass door added modeling to the dancer's form, and allowed relatively slow exposures to emphasize movement through blur.

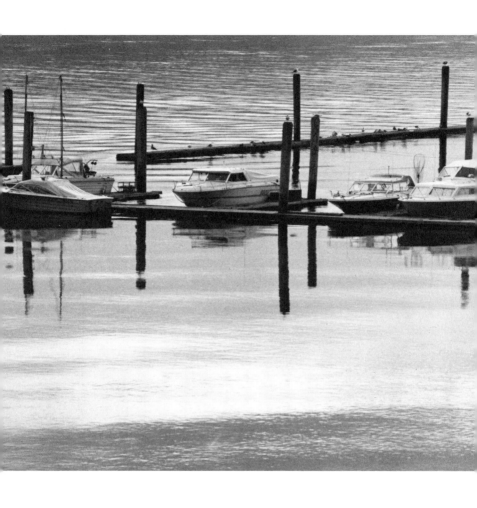

Fig. 1 — 9. The fascinating light of twilight was captured with a tripod-mounted camera and an exposure of 1/15 sec.

snowy Sierras in the background would be blah without sun. In other words, strongly directional sunlight is the best option for many scenic situations, although soft light may give landscape a romantic feeling in color.

2. Outdoors, or near a window indoors, a shady spot can be first choice for portraits, as seen in Fig. 1—7. Soft, indirect light is comfortable for the subject, and lets us view a face pleasantly. The young lady with chin on hand posed in front of a white wall, and the main illumination came from reflected sunlight from a concrete walk. A completely overcast day is also appropriate for portraits, but if the day is sunny, take your subject to a shady spot, preferably where there's some reflected light.

3. In limited light levels indoors, very directional light may be esthetically satisfying, as illustrated in Fig. 1—8. My friend practiced ballet steps in her living room beside a large sliding door at the left. For some of the series of pictures I planned the blur to emphasize motion, so a reduced light level in which I could shoot at 1/8 sec., 1/15 sec., and 1/30 sec. served my purpose well. Ordinarily, I would use a tripod for slow shutter speeds, but I wanted mobility here, so I braced the camera carefully against my chest. By exposing for the highlights, I could underexpose the background to be darker and dramatize the lady's figure and face.

If there's not enough room light for portraits or activities, you may add floodlights, which you'll read about in Chapters 3 and 4. Floods do not freeze action as electronic flash does, and you can see their effect on form before you shoot and while you're shooting. Floods give you a nice sense of control.

4. In limited light levels indoors or out, and after dark, the photographer's option is to use a tripod, or a similar firm setting, for the camera. Tripods give one a sense of confidence and adventure as well, as will be mentioned further, especially in Chapter 8. It's not only users of large view cameras and super-safe types who enjoy taking

pictures from a tripod. But you may already know that a firmly anchored camera is one sure-fire path to photographic self-expression in dim light especially.

My shot of a small boat harbor (Fig. 1—9) in late twilight would not have been sharp at all without a tripod. I was using an 80–200 mm zoom lens on my SLR camera, and the exposure was 1/15 sec. at ƒ/5.6 with Plus-X film (ASA 125*). Even if I had braced my elbows on the railing of the bridge where I was standing, I could not have been sure of the same sharpness guaranteed by the tripod. If you love working before sunrise and at dusk, you won't mind carrying a tripod to make such pictures possible.

5. Indoors (or anywhere it's fairly dark) where there's action, such as at a party, the existing light may be inadequate to make possible fast enough shutter speeds or small enough ƒ-stops, or both. In such a case, flash is the expedient light used by news photographers, wedding specialists, and all of us who bring light to the scene, whether it looks somewhat artificial or not. Thus when flash is inevitable, relax and use it, as I did in Fig. 1—10 of the card-playing sisters. Electronic flash freezes action on film, and is valuable for many situations such as sports, fast-moving children, or to capture the fleeting smile. Flash-on-camera is one way to go, but bounced flash is often pictorially preferable. For Fig. 1—10 I bounced a portable electronic flash unit off a white ceiling and avoided harsh shadows while illuminating both subjects evenly.

6. To complete this general list of lighting options, there are those situations which require time exposure. If there are moving people or objects, you may get decorative, or annoying, blurs, and when the scene is static, you discover how light is collected on film. Thus you flirt with chance, and create photographically illusions that the eye cannot see. Quality and quantity of light combine to give you wonderful slides and prints, when you can anticipate some of the results, and take the right risks.

SEEING THE LIGHT

Everything you learn about recognizing or applying light is obviously part of your photographic technique and increases your pleasure with a camera. As you read further, you can be doing other things to improve your consciousness about light. For instance, study some of the pictures in this book without reading the text or captions. Make an educated guess about what kind of lighting was used, what time of day it was, or how the light was directed. Play the same game of analysis with photographs seen in other books or magazines, or in exhibitions. Make critical judgments about lighting effects in such photographs in terms of "how could they be improved?" Are shadows too strong? Is there insufficient detail in them? If there are no shadows, how was that accomplished?

Ask yourself if the lighting in pictures you see is skillfully handled. Or is it too obvious? Too flat, too contrasty, or insufficient? How would you have changed the lighting if that were possible?

As you analyze light in pictures and before you shoot, you gain more awareness. Your intention is not to copy, but

Fig. 1—10. Electronic flash bounced from a white ceiling provided pleasing and uniform illumination on both young card-players.

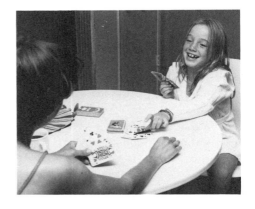

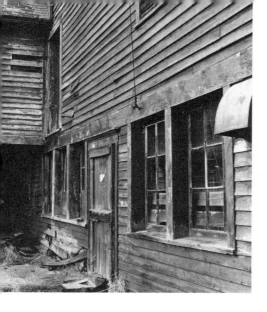

Fig. 1—11. When clouds cover the sun, the light is sometimes described as "flat," but Carl Talley won a Kodak/Scholastic Award by utilizing such light to bring out the textures in this old wood building.

to absorb the best influences and styles. In this process, you will look more critically at your own images to evaluate your use of light. That means to equate light with mood, form, texture, expression, composition, and other elements of visual excitement. Thus you may find yourself directing models more skillfully, or shifting a camera position to take advantage of a more promising lighting effect.

Light makes photography possible. In fact, the word *photography* comes from the Greek and means "writing with light." Fortunately, there are few rigid rules for lighting. Instead there are a number of sensible principles which should be considered flexible. In due time, all the theory will become part of your practice, and you will shoot with confidence where you once may have hesitated or backed away.

Now let's discuss exposure, through which *f*-stops and shutter speeds translate light into beautiful slides and prints.

2

The Basics of Exposure

To appreciate and master photographic light and lighting, you should be comfortable with relatively simple theories of exposure. Enough has been written about exposure systems to clarify some issues and confuse others. Well known is the zone system by which the photographer controls exposure and development in tandem. This can be very effective with individual sheets of black-and-white film, but for black-and-white roll film the theory applies only in a limited way, and it is useless for color unless you're the rare person who carefully develops your own color negatives and transparencies.

While you can successfully take pictures without a large technical vocabulary, it is helpful to recognize conditions of contrast, and it's nice to know what your exposure meter tries to do regarding contrast. Meters and films are terrific in the space age, but the photographer must still be in charge. Otherwise, you may be disappointed with slides too dark or washed out, or negatives that take exasperating manipulation to print. It's also gratifying to know that you can learn lighting techniques that help control exposure results, and that everything is influenced by how your meter "thinks."

Fig. 2—1. Lighting drama does not cause difficulties for modern built-in camera meters that neatly average highlights and shadows to provide proper exposure for all elements in a picture.

TYPES OF EXPOSURE METERS

There may be generations of photographers who have never handled an exposure meter because this light-measuring instrument is cleverly hidden within their cameras. In any case, an exposure meter uses a photoelectric cell to convert light into electrical energy which registers light intensity on a needle opposite a series of numbers or within a bracket. The brighter the light, the higher the needle or LEDs read on a scale seen in the viewfinder on a single-lens reflex camera. You adjust shutter speed, aperture, or both, for a proper exposure as indicated by needle, LEDs, or by direct *f*-stop or shutter speed readout for auto-exposure cameras. How you interpret this information is the nitty-gritty of exposure management.

Built-in camera meters and hand-held models that you point at a subject are *reflected light* meters. Most hand-

Fig. 2—2. Though contrast is part of this desert portrait of the author's wife, taken with a 4" × 5" view camera, predominance of middle gray tones simplifies exposure.

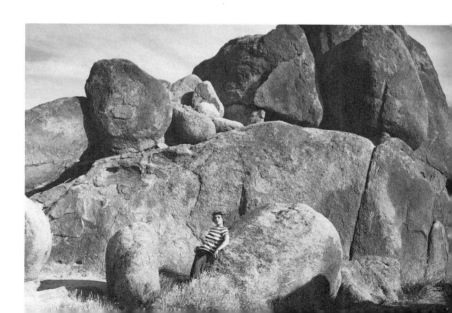

held meters can be converted to be *incident light* meters by slipping a small plastic diffuser dome over the opening to the meter's cell. An incident light meter is pointed at the light source, and held in a position that simulates how the light falls on the subject. *Both types* of meter measure and *average* the light reflected from or falling on the subject, depending on the meter. The key word here is *average*, as we shall see.

There is also a specialized *spot meter* which measures light reflected from a relatively small area within a scene, compared to the overall area covered by a built-in camera meter—varying according to the lens used.

In the past there has been much debate about reflected vs. incident light metering to determine which was "better" or more efficient. Today, while some meticulous workers may use a hand-held meter of one kind or another, the debate has subsided because the vast majority of photographers use (and are satisfied with) single-lens reflex cameras with integral reflected-light exposure meters. Therefore, I'll concentrate on how this type of meter "sees," though a hand-held meter operates similarly.

EXPOSURE-METER MEASUREMENTS

An exposure meter built into an SLR measures the brightness range of a subject seen through the viewfinder. Light passing through the lens strikes one or more metering cells which translate electromagnetic energy into exposure readings we hopefully understand. A few moments ago I mentioned that an exposure meter averages highlight and shadow areas, which means it combines all the light reflected from bright, medium-toned, and dark objects, and gives us a single exposure value for them. In any scene there is a *brightness range* which relates to *contrast* between light and dark objects, all of which is related to understanding and controlling light as you shall discover.

When a meter arrives at an average exposure, it is the

Fig. 2—3. Bright areas in high-contrast scenes such as this may tend to influence an exposure meter toward underexposure, so add half a stop for insurance.

equivalent to the exposure it would indicate for a middle or medium gray, scientifically established as an 18 percent degree of reflectivity—the standard average gray. You'll see the precise tone on a Kodak 18 percent gray card available at your neighborhood photo supply shop. You may already be familiar with the card if you do color printing where it also provides a tone standard.

Fig. 2—2 is a good example of an average scene which an exposure meter handles easily because middle-gray tones dominate the picture. Neither dark shadows nor bright highlights extend the brightness range to any great extent. Fortunately, in a large number of situations you'll find a relative equality of bright and dark tones which combine to become the average gray sought by an exposure meter, resulting therefore in quite suitable negatives and slides. This means you can often trust the camera meter without further fussing into concerns that please the technique-conscious and annoy the rest of us!

Fig. 2—3 is an example of a high-contrast subject with an extended brightness range. An in-camera meter

31

could be overly influenced by the position and brightness of the white wall, even though the shadows and dark shutters provide some tonal balance. If the white wall dominated the meter reading, underexposure would be indicated to render the wall closer to 18 percent gray, and a manual compensation might be necessary for proper exposure. Generally, dominant highlight or bright areas influence a meter to show one stop or more of underexposure, resulting in slides too dark and negatives too light or thin. Knowing this, add half a stop or a stop to the exposure for the extended brightness range of beach and snow scenes, for instance. If the aperture indicated is f/16, shoot at f/11 or between f/11 and f/16.

Fig. 2—4 represents a relatively low-contrast subject in the flat light of a cloudy day. There are good highlight and

Fig. 2—4. A low-contrast subject photographed under a cloudy sky will benefit from a half- or full-stop underexposure; this picture was taken on Plus-X film rated at ASA 125.

dark tones, but the range between them is decreased as compared to seeing the same subject in bright sun. An exposure meter trying to average this subject finds it predominantly dark, and therefore indicates overexposure to bring the tonal combination up to middle gray. Though your urge may be to give more exposure as the meter says, half a stop or a whole stop less exposure results in slides that have good color saturation and negatives of preferable density.

EXPOSURE TECHNIQUES

There are careful ways to deal with contrast extremes, also called the brightness range of a scene, and some of these are detailed for Figures 2—5 and 2—6:

1. Fig. 2—5 was shot with an 85 mm lens through which the in-camera meter reading for Plus-X film (ASA 125*) was 1/250 sec. at f/11. To second-guess the exposure, I began by reading the palm of my hand in bright sun as an equivalent to the bright corrugated roof of the Yugoslavian farmhouse. This is an easy substitute when you can't get close enough for a specific reading. The result was 1/500 sec. at f/11.

2. Next, I measured the reflectivity of the darkest important shadow area, such as the woodpile. This was also inaccessible, so I read the shadow beneath a large cabbage leaf in the foreground. You know such shadows will have minimum detail in the finished picture, unless they are especially meaningful, and then you would give them additional exposure. The shadow area reading was 1/60 sec. at f/11.

3. I could now select an exposure midway between the two extremes as a compromise: 1/250 sec. between f/8 and f/11, which is close enough to the overall meter reading to produce a slide or negative very similar in appearance. As

*See chart, ASA and DIN Film Speeds, p. 189.

Fig. 2—5. As an exposure check, the author took individual readings from nearby objects and compared the results to the in-camera meter recommendation for this Yugoslavian scene.

mentioned before, separate meter readings often average out to the exposure indicated for the entire scene. It is therefore no surprise that a large number of picture situations are photographed *without* special manipulations. The in-camera meter does an adequate job, and it's more efficient. However, it does pay to check highlight and shadow reflectivity when there's time to be more precise and the contrast range calls for caution.

4. Fig. 2—6 is another example of an extended brightness range that one wishes to compress in a black-and-white negative by slight overexposure and slight underdevelopment. One way would be to shoot a segregated series of images on a 35 mm roll, cut the roll, and develop

that section separately. Another method might be to use shorter rolls of film, or shoot with a camera such as the Rolleiflex (12 frames to a roll) as Alice V. Sebrell did for her Kodak/Scholastic Award winner. Alice may have bracketed exposures, which means to shoot the average and at least one other over and under the average of the same subject. Development may then be normal, and contrast can be influenced by your choice of printing paper grades.

Note: Over- and under-exposure–development manipulation does *not* apply to color slide film for which you should aim to get good color saturation in the highlights at the risk of losing some shadow detail. Color negative films respond best to slight overexposure, and are usually developed normally.

5. If the contrast in a scene is limited, as it was in Fig. 2—7, you need to *expand* the tonal range by underexposing and overdeveloping black-and-white film. At this abandoned movie set contrast was reduced in the shade. I took a meter reading on the shadow side of the model's face, and another on her bright sleeve, but ignored the patch of sky because there was no detail in it that I wanted to hold. I computed an average exposure of 1/8 sec. at f/32 on Tri-X (ASA 320*). Since this picture was taken on 4″ × 5″ sheet film, I could underexpose nearly a stop and overdevelop about 20 percent to expand the contrast range. With a 35 mm SLR camera I would have used the average exposure and shot half a stop and a stop less with black-and-white film. Had Fig. 2—7 been a color slide, I would have overexposed half a stop to improve shadow detail, and shot at the average as well.

Awareness of exposure techniques is what's important. You then have the choice of shooting quickly by meter measurements that average, or of taking time for plus or minus exposures to fit specific circumstances.

*See chart, *ASA and DIN Film Speeds*, p. 189.

FILM, LIGHT, AND CONTRAST

Neither black-and-white nor color films are capable of recording the extreme contrast ranges we sometimes photograph, and thus we experience over- or underexposure, even when we're careful. However, film does have *latitude* to compensate for exposure mistakes and/or extremes, but one should not depend on latitude to cover sloppiness.

As you learn to analyze light and subject contrast, you try to make choices about how a scene or subject *should* appear in tones and hues, and you evaluate it accordingly. Determine whether brightness or darkness *dominates* the situation. If you photograph a few dark branches in snow, the meter will indicate underexposure to render the snow as

Fig. 2 — 6. An extended brightness range as exhibited in this photo by Alice V. Sebrell, may be handled by slight overexposure and slight underdevelopment; alternatively, bracket exposures, develop them normally, and control contrast by choice of paper grade.

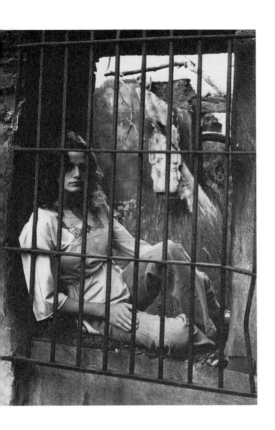

Fig. 2—7. Exposure notes for this situation, where the tonal range was compressed, are in the text. The photo was taken with a 4" × 5" view camera and 8" lens.

middle gray instead of glistening white. You must use a larger aperture or slower shutter speed, or both, to compensate. In reverse, a dark object against a relatively dark background stimulates the meter to indicate too much exposure in order to bring these tones up to middle gray. Here, you must use a smaller aperture or faster shutter speed, or both. As a personal exercise, find high- and low-contrast situations, shoot comparative exposures of each, keep notes, and discover through direct experience how an exposure meter searches for the average middle gray that may or may not be correct for you.

Fig. 2—8. By bracketing, the author was assured of at least one well-exposed negative of this scene with its extremes of lighting contrast.

BRACKETING

When in doubt about exposure, it is good practice to *bracket*, which means to shoot half a stop, a full stop, or more, over and under the exposure indicated by the meter. You bracket when there's time, and when a photographic opportunity seems important enough. As you become experienced, you may bracket in one direction only, or by one specific amount only. For Fig. 2—8 I bracketed one stop on either side of the meter reading, because I was not certain how much the bright reflection of the sun would influence exposure, since it was far off-center. With *f*/16 at 1/250 sec. the indicated exposure for Plus-X film, I shot at *f*/16 at 1/500 sec. and *f*/11 at 1/250 sec., and the latter combination yielded the best negative.

Fig. 2—9. Light coming from a window and an open roof combined to create interest in this photograph where extreme contrast of light and shadow was intentional.

WHAT IS CONTRAST, ANYHOW?

This is a strange question on which to conclude, but contrast needs clarification. For years I have heard about "contrasty light," in terms of the sun, flash, or floodlights used in a certain way, and I've made a few observations I want to share:

1. Strong or intense light is only "contrasty" when it creates pronounced shadows, as seen in Figures 2—9 and 2—10. You might imagine that the sun coming through a window in Fig. 2—9 could be replaced with a powerful floodlight or flash to produce a similar effect. The light makes a distinct light and dark pattern on the model, appears as a patch on the floor, and bounces around the room pleasantly. Contrast is a product of the direction of light, but it also comes from the varying tonality of the subject. As a further example, place a white rock on white sand in overhead sun, and there is little subject contrast. Substitute a black rock and add some medium-dark leaves, and subject contrast increases considerably, though the lighting does not change.

2. From the above remember that dark-against-light and light-against-dark is a photographic concept of continuing importance, for contrast is the explanation for tonal *separation*. We see forms separately because of their tone (and hue), as well as their indigenous shapes, because of the way they are lighted.

3. To further illustrate, or preview what you'll see in the next chapter, aim a light from the camera at someone close to a medium-gray wall, and with minimal shadows there is minimum contrast from the light. Position the same light to one side, pull the person away from the wall which then becomes darker, and contrast increases. The model also *separates* from the wall at least on the highlight side.

4. As an example of both subject and light influencing contrast, look at Fig. 2—10 which includes a normal range of tones in distinctive separated shapes. Dark areas are

40

created primarily by shadows, however. Now imagine the same scene without sun when the shadows would be soft and blend into other tones. The quality of the light would influence contrast despite the reflectivity of the subject.

5. Imagine Fig. 2—10 in color with the main central box-shape a brilliant yellow, the grass medium-green, and other bright colors for remaining forms. Now contrast would be shared by both hue and shadows. It follows that in color, forms separate more readily because of contrasting hues,

Fig. 2—10. Object shapes and patterns of light create a semi-abstract situation that would have its own character in color as well.

whether there are value contrasts or not, coming from a directional light source. If you want to start a lively debate among your photographer friends, simply state that color is "easier" to shoot than black-and-white, or vice versa. Opposition to either position will be instantaneous!

Thus is exposure related to light and lighting. To strengthen your understanding, experiment with exposure in different kinds of light, and from varying directions, and notice what happens on film that you did or did not anticipate. In time you will learn that lighting solutions are predictable, and so is exposure, when you and your equipment work as one. The "mysteries" of exposure and light are slowly solved when you are in charge.

3

Lighting for Form

As I have mentioned, light as it appears in nature or is applied by you is usually a combination of practical and beautiful. Awareness of light helps us to take advantage of its esthetic qualities, which are closely related to this most important chapter where we analyze *what light does to form*.

From the pictorial demonstration spread throughout this chapter, you should discover two basic lighting skills: recognition and control. Outdoors, or wherever you shoot by ambient light, you will recognize the character of the light, how it affects the form and feeling of your subject, and whether you need attempt to alter it or use it as is. Indoors, particularly where you apply flash or floods, you will feel confidence in placing lights because you know in advance how to control what they do to a face, or whatever you are photographing.

Especially, you will study shadows; they reveal or indicate the position of lights or, as in Fig. 3—1, the location of the sun. It is clear from the shadows that the sun is fairly high and slightly to the right of the camera. You can often determine where the light comes from in portraits because

the nose is a sundial, and its shadow is the best clue to the direction of light, artificial or natural.

In Fig. 3—1 and in many other illustrations in this book, light also influences mood and other pictorial qualities of a scene or portrait. Thus, while you study the progressive lighting exercises and examples that follow, though I emphasize the *direction* of each light in terms of what it does to form, keep in mind the esthetic and psychological implications of lighting effects, even if I do not point them out.

This is not a book about portraiture, but this chapter could be titled "Lighting a Portrait," since that's what it's about. However, I do not attempt to interpret the model's personality, though it is often worthwhile to make a statement about your subject through lighting, posing, expression, and your rapport with the person.

DUAL EXAMPLES

As I discuss the direction and form-revealing aspects of lighting a portrait, I relate applied light to effects found in

Fig. 3—1. High, overhead sun created the light-and-shadow formations for this atmospheric setting, photographed with a 4″ ×5″ view camera at an abandoned movie set.

natural circumstances. From this we see that no lighting is exclusive to a specific location or subject; there is strong directional light or soft, diffused reflected light outdoors as well as indoors where it's within your control. In addition, there is no "perfect" lighting, though there are ideal lighting conditions, subject to personal taste. I may be enthusiastic about soft lovely light in certain illustrations, but you may find it bland. It is important that you should be familiar with many lighting variations, so you have choices, and can exercise controls for personal expression and pleasure.

ABOUT MY PORTRAIT SETTING

The demonstration series, beginning with Fig. 3—2, was photographed in my living room after moving furniture away from a white wall, and placing the model on a high bar stool three feet from the background. My lights were as follows:

2 reflector flood bulbs, each 500 W, attached to adjustable clamps on light stands.

2 Smith-Victor 650 W quartz lights on stands.

2 white fabric umbrellas, one 36-inch Larson Reflect-asol, and one 36-inch of unknown brand.

1 Larson Strobasol X8000 electronic flash unit.

There's more data about this and other lighting equipment in Chapters 4 and 5.

The camera was a Konica T4 with 65–135 mm Hexanon zoom lens set at about 100 mm and 105 mm. The focal length was varied, so that neither the tripod nor the model had to move. The film was Plus-X developed in Microdol-X.

All the portrait exercises through Fig. 3—22 were made with floodlights. Figures 3—23, 3—24, and 3—25 were shot with a single Strobasol electronic flash which is uniquely designed around a long hole in its center through

which the shaft of an umbrella can be inserted. The quality of a medium-sized electronic flash reflected into an umbrella is slightly different from the look of a quartz light in the same position, probably because the flash is larger in diameter and offers a 1/1000 sec. exposure that precludes any subject movement that may occur at 1/60 sec., the shutter speed used for the floodlight shots.

LIGHTING DEMONSTRATION

Front light (Fig. 3—2 and 3—3). One floodlight was placed as close to the left side of the camera as possible for Fig. 3—2. There's a telltale shadow behind the model, similar to the shadow cast by a flash unit mounted atop your camera, and there's a slight shadow under the chin. Front light is rarely flattering, and it tends to flatten form as well. Shadows, which delineate form, are minimal or absent with front light at or near the camera.

Fig. 3—3 is an outdoor example with the sun slightly to the right of camera and fairly low. In this case the tiger separates adequately from the background, and its form and texture are suitable, but a tiger is different from a lady, and front-lighting for people is not recommended.

Front light plus background light (Fig. 3—4). The main light beside the camera in Fig. 3—2 hasn't been moved, but another 500 W reflector flood now illuminates the background wall. Thus the shadow behind the model is eliminated, and the head is nicely separated from the background, but this is still of limited value for portraits. By the way, if you cannot light a background easily, place your model in front of a window diffused by translucent drapes or blind, or use a wall that is already strongly lighted.

Sidelight (Figures 3—5, 3—6, and 3—7). In Fig. 3—5 one floodlight is now about four feet to the left of the model and level with her head. In Fig. 3—6 the background light

Fig. 3—2. Front light, with a floodlight immediately alongside the camera, is not flattering for portraiture and tends to flatten the subject.

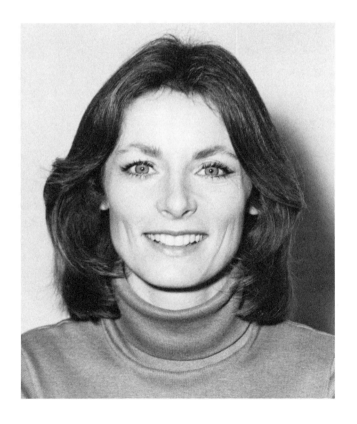

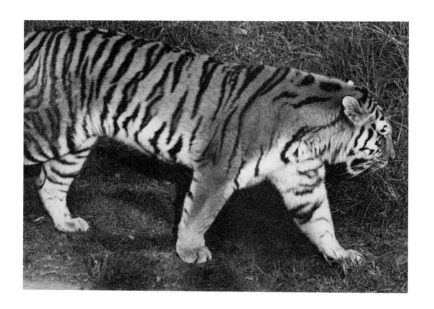

Fig. 3—3. Where form and texture are suitable, frontlighting may be adequate, especially where the subject is not easily controlled.

has been added. In Fig. 3—7 sidelighting comes from windows to provide an intriguing portrait of artist Lee Hill adjacent to her studio. Sidelighting in such natural circumstances as this, or in a landscape or cityscape, can be beautifully dramatic, and might be suitable for a male face, but it's too harsh for my pretty model. Sidelight splits her face along its centerline, but contributes questionable mood value. However, the direction of the light is intrinsic to the atmosphere of Fig. 3—7. Take advantage of sidelighting for memorable photographs where it's the right light.

Sidelight and background light plus fill light (Fig. 3—8). The lighting for Fig. 3—6 is here augmented by fill light, meaning another light source to fill or illuminate shadows. A quartz light reflected from a white umbrella about three feet

Fig. 3 — 4. Addition of a background light to front-lighting helps separate the subject from the background and eliminates unwanted shadows.

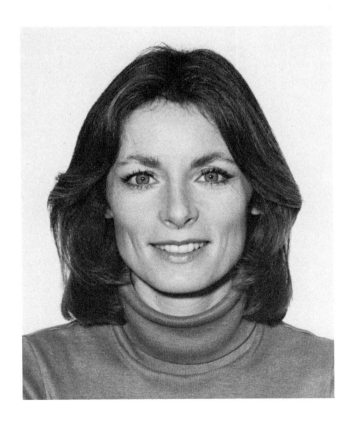

49

Fig. 3—5. Sidelighting alone is generally too harsh for portraiture.

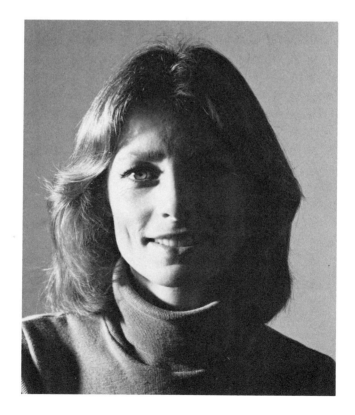

Fig. 3—6. Addition of a background light to a sidelight provides more contrast between model and background, but does not improve the harsh effect of the side light.

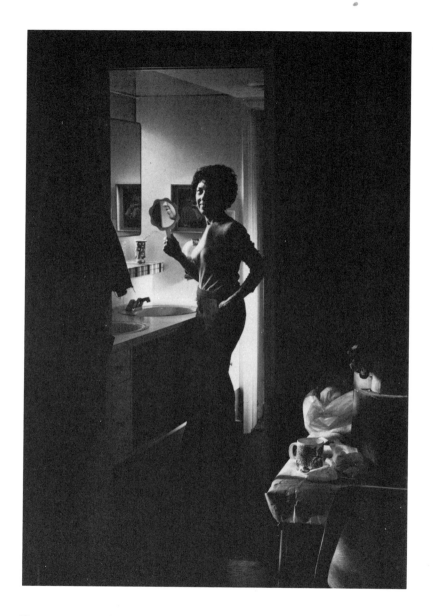

Fig. 3 — 7. Natural sidelighting provides drama and mood in a situation where it is used appropriately.

from the model was enough to brighten the shadow side of her face without creating objectionable new shadows. As you can see, the stronger light, called the *key* or *main* light, is dominant, while the fill light is weaker and subordinate. This suggests a guiding principle for lighting portraits and many other subjects: Lights of equal intensity and distance from the subject tend to flatten form, and may also create conflicting, undesirable shadows. Thus, in good lighting practice, the fill light is either farther from the subject than the main light or it is less bright by reason of its wattage (light output in terms of electronic flash), or because it is reflected rather than direct.

At this point I suggest that the reader plan to shoot a series of lighting exercises such as these, in order to personally experience the effects discussed. Shoot color or black-and-white, but be systematic. Compare direct and reflected lighting, move the key lights and the fill lights to the configurations shown, and add your own variations. It might be a good idea to keep notes via little diagrams to identify exactly the lighting patterns used for specific photographs.

Bottom light (Fig. 3—9). One floodlight was positioned about three feet from the model's face, almost at floor level, giving her a sinister appearance, mitigated by her bright smile. I'm not recommending bottom light for any but bizarre reasons, yet it is enlightening to see how the mere placement of a single light source can change a person's guise.

Top light (Figures 3—10, 3—11, and 3—12). Now the main light is above and slightly in front of the camera, as clearly indicated by the nose shadow. The light is back far enough to avoid dark eye sockets, but heavy shadows under the model's mouth and chin are unpleasant. In Fig. 3—11 a weak fill light has been added, enough to overcome some of

53

Fig. 3 — 8. Use of a fill
light, not as close to the
subject as the main light,
illuminates shadows
without flattening form.

54

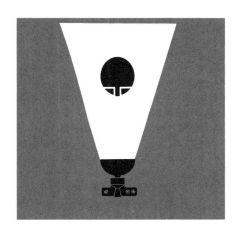

Fig. 3—9. Bottom light may be used for special effects, but is not advisable for normal portraiture.

the heaviness in Fig. 3—10. When you shoot these exercises, vary the intensity of the fill light, and discover how many different effects you can create.

High overhead sunlight is a top-light situation as seen in Fig. 3—12. As so often happens, photography was unavoidable at this time of day. Had I been more careful, I might have asked the subject to tip her head back slightly, to separate the nose shadow from the upper lip. On the other hand, the high sun does show the woman's character lines, and makes her rather imposing.

Forty-five-degree top light plus fill (Figures 3—13, 3— 14, and 3—15). The single main light was shifted to the left for Fig. 3—13, which is a more typical position for portraits. Without a background or fill light, Fig. 3—13 is less interesting than the top-light effect in Fig. 3—10, but with added fill and background lights, Fig. 3—14 is preferable to Fig. 3—11. Of course, there are an infinite number of variations for the main light, to accent eyes, cheek bones, a smile, or other features.

Move your lights around with care, and shoot many changes for the practice. You may prefer indirect or bounced light for portraits as I do, but it's important to know how direct light from many directions affects a face or a form, such as the dancer in Fig. 3—15. Here the sun shines from a 45-degree angle, revealed by the shadows that become integral to the image. This time of day was chosen specifically to shoot this series of dance poses at a curved building under construction.

Backlight (Figures 3—16 and 3—17). One floodlight behind the model at camera left in Fig. 3—16 illuminates the background as well. The result is a silhouette, the kind that in Fig. 3—17 tells a graphic story quickly. Here instinctive good timing with a telephoto lens helped Anne D. Sielinski win a Kodak International Newspaper Snapshot Award for capturing the leaping dog in midair.

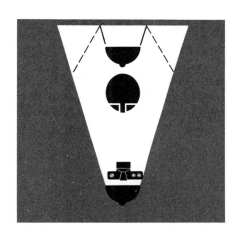

Fig. 3—10. Top light alone creates heavy and unflattering shadows.

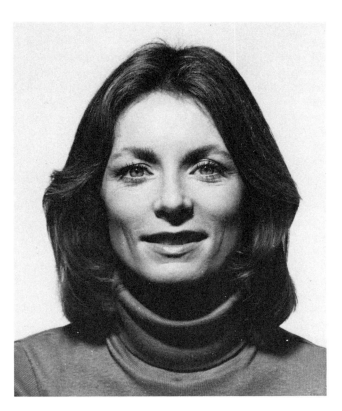

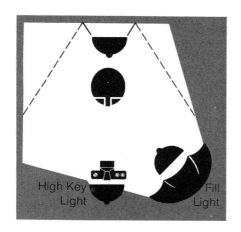

High Key Light

Fill Light

Fig. 3—11. Addition of a weak fill light to top light eliminates some of the shadows.

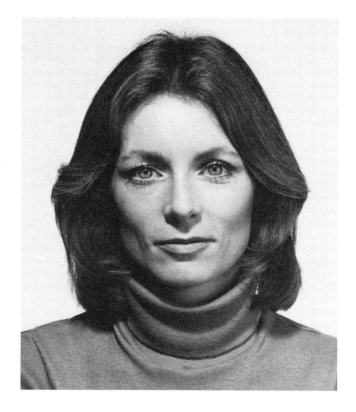

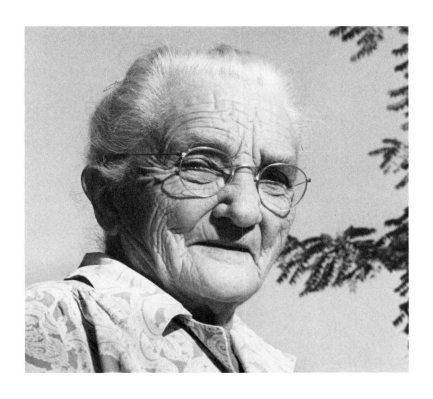

Fig. 3—12. High overhead sunlight was not entirely flattering to this subject, but added interest and character to her features.

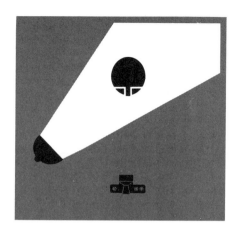

Fig. 3—13. Angled top light is more flattering for portraiture than direct top light.

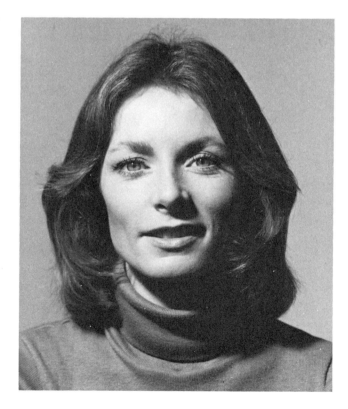

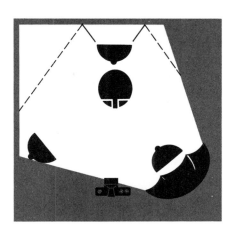

Fig. 3—14. Addition of background and fill lights to angled top light accents the model's features and eliminates unwanted shadows.

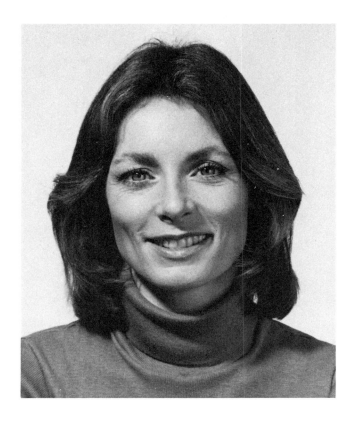

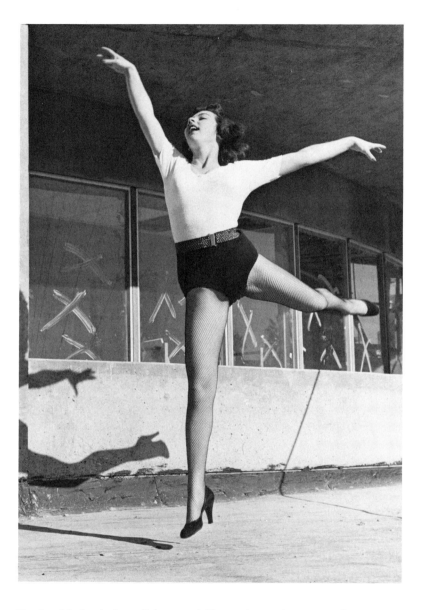

Fig. 3—15. Angled top light was deliberately used to create the
interesting shadow effect of this picture.

Fig. 3—16. A partial silhouette was created by placing a single floodlight behind the model and slightly to the camera's left.

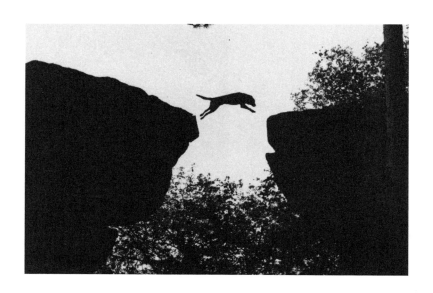

Fig. 3—17. Natural backlight was ideal for this dramatic scene.

Backlight with forty-five-degree and fill lights (Figures 3—18, 3—19, and 3—20). Without moving the light behind the model in Fig. 3—16, I added a high 45-degree light plus reflected fill light for Fig. 3—18, a combination more suitable for a masculine face. Preferable for my model is reflected fill alone, as seen in Fig. 3—19. It helps to have your model turn his or her head toward the reflector, for a relatively even effect. You may also bounce or reflect two lights equidistant from the model on *each* side of the camera; if done skillfully, shadows may all be eliminated for a soft, flattering light.

Backlight is responsible for drama, as exemplified by Fig. 3—20 of musicians at the Piazza San Marco in Venice. It's usually a delight to shoot where light glances off objects such as the instruments, and edge-lights subjects as it does

Fig. 3—18. Backlight supplemented with forty-five degree and fill lights is revealing and may be more suited to a masculine face.

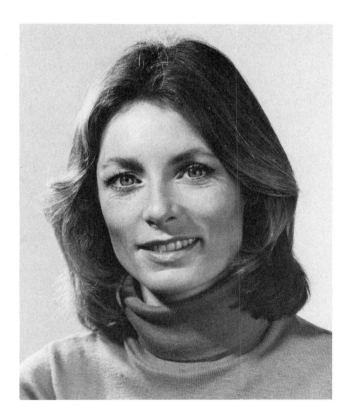

Fig. 3—19. Backlight and reflected fill light is more flattering to a female face; backlight adds an attractive highlight on the hair when the model's face is turned toward the fill light.

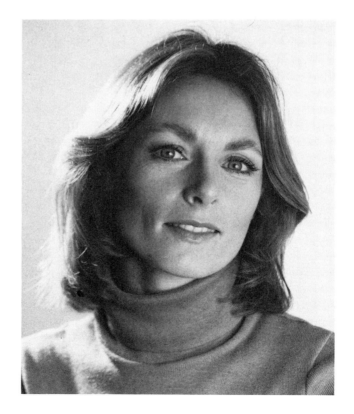

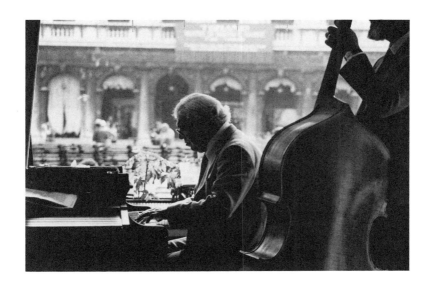

Fig. 3—20 (above). Backlight may be very dramatic, especially when it adds edge light to the subject. Fig. 3—21 (below). Bounced flash gives softer, more even illumination than direct flash on camera, and creates a lighter background.

the pianist. One stop of added exposure often compensates for strong backlight; here overexposure and soft focus help to subdue the background as well.

Backlighting separates people from their backgrounds; it adds an accent to portraits and to small objects and food, which have more eye appeal. Look for backlight to improve existing situations that might otherwise be undistinguished.

LIGHTING VARIATIONS

Lighting categories in terms of direction and intensity are essential to recognition and control, but lighting is like lasagna in that there are many agreeable recipes. One of these is a variation of reflected light called bounced flash, represented by Fig. 3—21, and noted again in Chapter 5. By pointing a flash unit at the ceiling or at a wall, you create an instant reflector for softer, more even illumination than direct flash on the camera can offer. A small electronic flash unit was aimed above and in front of the model for Fig. 3—21, and the light bounced around the room as well, creating an effect preferable to the dark background of direct flash. This is also a good way to illuminate groups of people more uniformly, and give your pictures some distinction.

Small objects or still lifes with reflecting surfaces usually require reflected light, and that's how I shot the camera in Fig. 3—22 for my *Konica Guide* (Amphoto). The background is a piece of heavy white paper curved up and behind the subject-camera. Illumination was two quartz lights aimed at a piece of white cardboard held above and slightly in front of the subject. You see a reflection of the cardboard in the lens. While observing the subject through another Konica with macro lens attached, I maneuvered the reflector until I saw the effect I wanted, and made my exposures. When I needed two hands to hold the reflector, I exposed by self-timer. Since the exposure meter was strongly influenced by the white background, I divided the

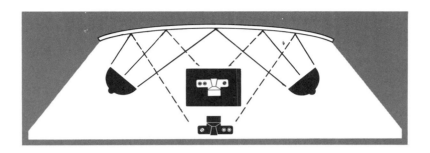

Fig. 3—22. Reflected light is required for photographing small objects or objects with reflective surfaces because it eliminates glare and shadows.

film's ASA rating in half. This gave me suitable detail in the black camera, and a clean white behind it.

Also, one may place small objects on glass suspended over a suitable background with space enough to allow placement of lights directed at the subject from above, and separately on the background. Shadows are obliterated except on the still life itself.

Silver, glass, and other highly reflective materials also may be photographed in an enclosure called a "tent" which surrounds the subject with reflecting surfaces. Lights are directed strategically, and a hole may be cut in front of the tent for the camera lens. A tent may also be made of translucent material lighted from the outside. Reflection control is tricky, but is feasible with experience.

PORTRAIT VARIATIONS

At the end of my lighting exercises, I shot a few portraits for fun. Figures 3—23, 3—24, and 3—25 were all taken with the Larson Strobasol X8000 electronic flash reflected into a 36-inch Reflectasol umbrella. Opposite the flash I placed a second umbrella to reflect light gently into the shadows.

For Fig. 3—23 the flash was at camera right about four feet from the model, and a floodlight was aimed at the background, which is slightly gray because of the f-stop and shutter speed used. When you mix flash and flood, you can control the floodlight effect by exposure manipulations. For instance, I shot at f/11 for Fig. 3—23, using 1/15 sec. to get a light gray background; at 1/30 sec. or 1/60 sec. the background would have been relatively darker.

For Fig. 3—24 the main reflected flash is still at camera right, but is closer to the lens, so that the face is less shadowed. Finally, the umbrella and flash were shifted to camera left for Fig. 3—25, the light was raised and tilted from perhaps a 40-degree angle—indicated by the nose shadow. Fill light came from another umbrella at right reflecting the main flash.

Fig. 3—23. This portrait was taken with reflected electronic flash placed to the subject's right. A floodlight was aimed at the background.

Fig. 3—24. Placing the main reflected flash closer to the camera than in Fig. 3—23 resulted in less shadow on the model's face.

Fig. 3—25. Fill light coming from a second umbrella softens indirect light flatteringly.

A FEW CONCLUSIONS

With a model plus a number of other subjects, you've seen how *light affects form*. High, low, front, side, or back, wherever you place lights, you will see shadows and highlights that distinguish faces and still lifes, and separate one form from another.

There are no iron-clad rules for proper lighting, but there are guidelines. You may have read that for portraits the fill-light to main-light ratio should be 4:1 or 3:1 or 2:1, but a ratio depends on personal taste, which is arrived at by careful observation of shadows in relation to form and highlights. Therefore, I do not deal in numerical ratios because they can be confusing and restricting.

Lighting direction is one thing. Sharpness or softness of light is another. Compare Fig. 3—13 to Fig. 3—25. In the former the direct light is sharper, and in Fig. 3—25 the indirect light is softer. I prefer the latter as being pleasanter for portraits, and for a lot of still lifes, but this is not a rule. It's a guide to successful lighting technique to be followed subjectively.

Light is an expressive tool which you can control, and which everyone can appreciate. You have many options for direction, balance, and type of light source. How you combine these options represents the quality of your lighting skill. For portraits, the light may be soft and mellow, but for other subjects, it may be crisp and definitive. You learn from experience, and from observing all the time in real life, in magazines, in books, and at exhibits. Practice breeds satisfaction. You owe that to yourself.

4

Floodlighting Equipment

Chances are that the average reader may own one or more electronic flash units, but have no floodlighting equipment because there hasn't been any apparent need for it. Well, there are needs to consider. As emphasized in the last chapter, *light you can control* is the key to learning what it does to form and texture, all of which affect composition and pictorial impact. With several floodlights, you can become familiar with basic techniques which also apply to electronic flash, and are closely related to the many forms of daylight we face regularly.

Floodlighting equipment may be as simple as one bulb in a reflector, or as complex as banks of quartz lights complete with diffusers and barn-door masks. Lighting units are sold separately or in kits, as seen in Figures 4—4, 4—6, and 4—7. When considering what you may need, here are some basic questions to ask yourself:

1. *What are you going to shoot with floodlights?* If you plan to do only medium and small still-life setups and portraits, a minimum selection of equipment should be enough. If you must illuminate whole rooms or groups of people, you will need more light output, meaning larger and more expensive units.

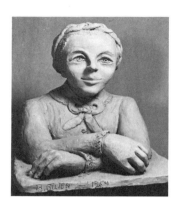

Fig. 4—1. One floodlight above the sculpture and to the right, plus a second light faintly illuminating shadows, brought out the form of this terra cotta work by Bacia Gilien.

2. How much do you want to carry and store? If you shoot mostly around home and have suitable storage area, buy whatever suits your fancy. However, if you need portability, and must pack a lot into the trunk of a small car, think in terms of lightweight stands and compact reflectors or lighting units, plus a case or two in which to carry them efficiently.

3. What's your budget? It's easy to spend $400 or $500 for a series of versatile floodlights with stands, cases, and so on. You may also find or devise less expensive equipment as noted below.

BASIC FLOODLIGHTS

The average photographer has several options in choosing adequate variable floodlight equipment. These options include the following:

Reflector flood bulbs. Two 500 W reflector bulbs (rated 3200 K) can be seen in paper sleeves at the left side of my lighting case in Fig. 4—2. These bulbs are self-contained, and can be used in a homemade assembly, as seen in the foreground in front of the case. Buy a clamp (Aligator,

Colortran Gaffer Grip, or something similar), attach a socket to the clamp, plus a wooden handle available at most hardware stores. Add 10–20 feet of wire with a plug at the end. For perhaps $20 you have a compact lighting unit that will clamp to a stand, table, shelf, or anywhere else that is convenient. If you prefer to buy the assembly ready-made, Smith-Victor has one, Model 100UL, shown at the top center of Fig. 4—3.

Floodlight reflectors. These are made in sizes such as 5″, 8″, 10″, and 12″ as seen in Fig. 4—3, for use with No. 1 and

Fig. 4—2. The author's case of lights includes two quartz units, three clamps for reflectorflood bulbs, stands, clamps for flash units, and extension wires.

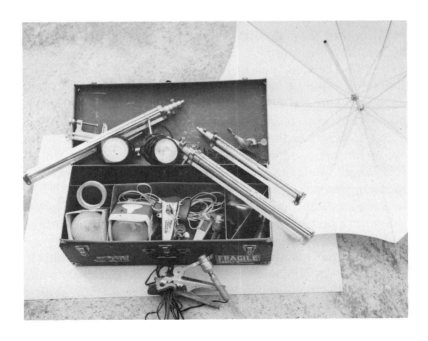

No. 2 photoflood bulbs. A 12-inch reflector for a No. 2 bulb including wire may cost $12–15, and can be clamped to a light stand or attached by means of a mounting stud. Photoflood bulbs cost less than reflector flood bulbs, but metal reflectors require more room in a storage case. Smith-Victor's K6 kit, shown in Fig. 4—4, weighs 16 pounds, and is carried in a medium-sized box. Cooler-operating Smith-Victor "studio lights" seen in Fig. 4—5 cost and weigh more than those in Fig. 4—3, but are stable and convenient in a stationary situation. The units in Fig. 4—5 lend themselves to more precise adjustment, and the bulb may be push-pulled to obtain a flood or spot effect.

Floodlight bulbs. The No. 1 size is 250 W and the No. 2 flood is 500 W. These and reflector flood bulbs are manufactured in two types: Conventional photoflood bulbs are rated at 3400 K for use with Type A Kodachrome, negative color and black-and-white films. These bulbs have a three-hour life, and tend to blacken as they age until the point where they should be replaced for color work even before they burn out.

The second type of bulb (No. 1, No. 2, and reflector floods) is rated at 3200 K for use with Ektachrome films, negative color and black-and-white films. Known as 3200 K bulbs, they cost more than ordinary photofloods, but last about 15 hours without darkening. Therefore 3200 K bulbs are recommended for their consistency and economy, unless you shoot tungsten-type Kodachrome now known as Kodachrome 40.

Floodlight bulbs are inexpensive when compared to the quartz bulbs described next, but they are not as bright, and they are bulkier to store and carry. However, they are useful for many purposes, and you may replace the bulbs in ordinary room lamps with No. 1 flood bulbs to simulate and intensify the ambient lighting in order to use a faster shutter speed and/or a larger lens opening.

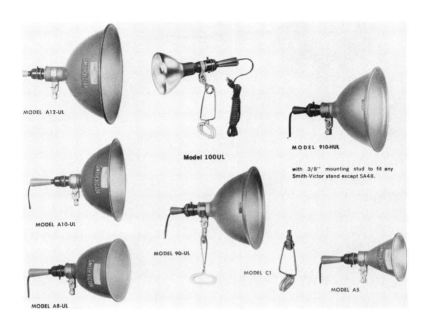

MODEL A12-UL

Model 100UL

MODEL 910-HUL

with 3/8" mounting stud to fit any
Smith-Victor stand except SA48.

MODEL A10-UL

MODEL 90-UL

MODEL C1

MODEL A5

MODEL A8-UL

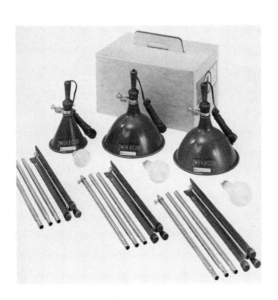

Fig. 4—3 (above). An
assortment of Smith-
Victor reflectors, which
are available in most
photo supply shops. Fig.
4—4 (left). This typical
lighting kit, which weighs
16 pounds, is an easily
portable combination.

Fig. 4—5. Smith-Victor refers to these as "studio lights" because of their large size and adjustability.

BASIC QUARTZ LIGHTS

Quartz units, seen in the lid of my lighting kit (Fig. 4—2) and in Fig. 4—6, are more compact than flood bulbs in reflectors; but, even so, they are rated at 600 W or 650 W, and available in either 3400 K or 3200 K ratings. Thus quartz lights are favored by photographers who want to carry several units in a relatively small case, and because their extra brightness is an advantage with slow films, when lights are reflected, and when you must illuminate a fairly large area. Quartz units and replacement bulbs cost more than floodlights, but they maintain their intensity for 20 hours or longer.

In Fig. 4—6, the kit at left lists for about $200 (in 1978), while the one at right, with heavier stands plus barn doors (available as a separate accessory for the left-hand kit) lists at $350. Both are by Smith-Victor, and may be more economical than buying the components separately, so compare prices. Smith-Victor and other companies also make 1000 W quartz units, such as the one at right in Fig. 4— 7 which is part of the Berkey Colortran Flight Kit/Mark 2, listing at $800. These are professional-type units which the average photographer doesn't need, but it's nice to know about them just in case a special occasion or job comes along.

For descriptive data and price lists of the lighting units above and the accessories below, here are some references:

> Berkey Colortran, 1015 Chestnut St., Burbank, CA 91502.
> Calumet Photographic, 1590 Touhy Ave., Elk Grove Village, IL 60007.
> Smith-Victor Sales Corp., 301 N. Colfax St., Griffith, IN 46319.

STANDS AND ACCESSORIES

Telescoping stands for all kinds of flood and quartz units are available in many sizes, weights, and prices. Fancy stands may have casters to roll them over a studio floor, and those with more sections cost more, but will extend to greater heights. Steel stands cost less, but weigh more than those made of aluminum. Choose what you can afford, at a weight and size you feel like carrying. A good light stand should last indefinitely, like a good reflector or quartz unit. Therefore, avoid equipment that seems flimsy in favor of lights that will last, and you'll save money in the long run, even if you spend more at first.

CUSTOM AND READY-MADE CASES

Ready-made fiber or aluminum cases sold in camera shops or discount stores may be quite suitable for your lighting equipment. In addition, some of the lighting equipment

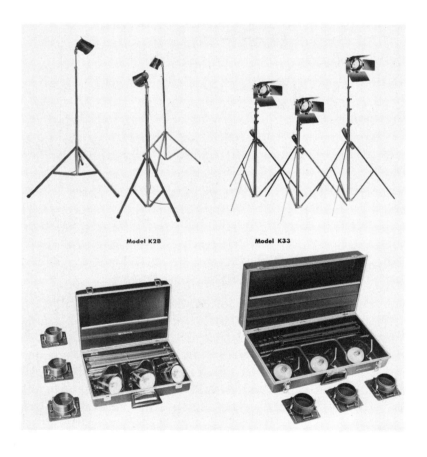

Model K2B Model K33

Fig. 4—6. Handy quartz light kits such as these are lighter, more intense, and cost more than floodlight reflectors and equipment.

companies mentioned previously sell their sturdy cases empty.

In metropolitan areas there should be companies making cases to order for lighting or other photo equipment. Check the Yellow Pages under "Photographic Equipment and Supplies." Years ago the case seen in Fig. 4—2 was made for me by an outfit in Los Angeles which is no longer in business. They laid out my lights and stands, drew a plan around them, and constructed the fiberboard container to hold everything snugly. A little research may turn up a similar local service for your lights.

BARN DOORS

In Fig. 4—6 notice the masks attached to the lights in the K33 kit. These masks, called "barn doors," are also seen folded in front of the right-hand case, and to the left of the K2B case at left. Barn doors are used to mask off or modify light in any direction. They clip onto a lighting unit and may rotate for full versatility. Some types have slots into which you place a diffuser (also called a "scrim"), or a colored filter for special effects. However, unless you do a lot of serious small-object or portrait photography, you will not need barn doors to take effective pictures.

DIFFUSERS

Made of heavy-duty plastic or fiberglass, or of wire screening, a diffuser softens the light, as demonstrated in Chapter 3. Diffusion is valuable for many subjects, along with or instead of reflecting the light. Because floodlights and quartz bulbs become extremely hot, diffusion materials have to be tough and durable. Don't try to substitute a handkerchief, for it will burn quickly. Check about attaching a diffuser to your floodlight or quartz unit, for you may need a special accessory to make it possible. The same accessory might also be used as a filter holder for a colored filter. Such holders are often part of a barn-door assembly.

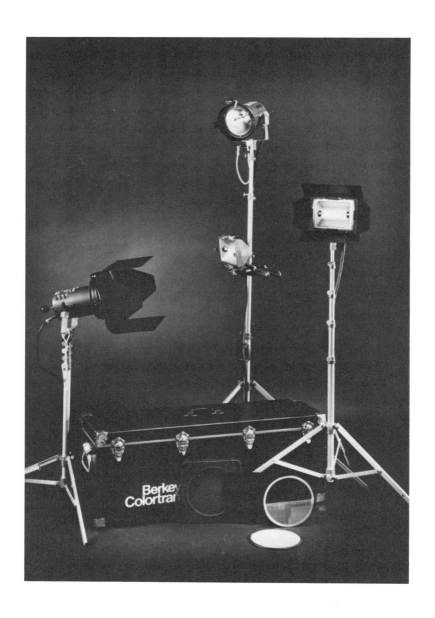

Fig. 4—7. Larger, more sophisticated lighting equipment is compact and very useful for motion pictures as well as still photography.

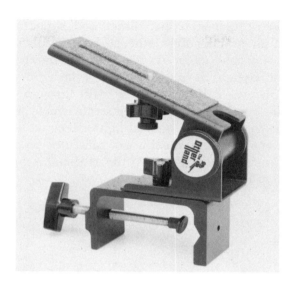

Fig. 4—8. The Other Hand is an exceedingly versatile clamp for lighting equipment and cameras. See text for data.

CLAMPS

Several have been mentioned, and more are available at camera shops. Be sure the clamp you buy is large and firm enough to hold the weight of the lighting unit involved. One superior clamp called The Other Hand (See Fig. 4—8) will hold a heavy light or a camera, and is convertible to many positions. It's available by mail order from Photoline Corp., 1307 S. 7th St., Aberdeen, SD 57401. Such a clamp will neatly hold electronic flash units as well as floods.

A FINAL WORD

If you almost skipped this chapter because floodlight equipment seems superfluous, I hope you have gotten my message that it's not. One cannot be really adept with light and lighting until he or she has worked with one, two, and

three flood or quartz lights, direct and reflected. If the equipment seems a needless expense, buy it with a friend or two, and alternate using it. It's easy to shoot by some variation of daylight or to use electronic flash, but that's not enough. You owe it to yourself to train through exercises with floods or quartz units in order to anticipate what flash will do and to appreciate natural light effects you discover. Start with one or two lights. Budget carefully. Be comfortable with your equipment. This is the artificial light you can see *before* you shoot.

5

The Facts of Flash

In the early 1960s when I first wrote about lighting there were a few relatively small electronic flash units, none with auto-exposure (it had not been invented), and none as versatile as those made today. Prices were higher for less light output, and the primary problem was calculating exposure. Unless you used an expensive electronic flash (EF) meter, the only way to determine flash exposure was by guide number. Since that technique is valid for some applications today, let's begin with it briefly.

GUIDE NUMBERS

A guide number is established by the manufacturer of an electronic flash unit, and is often revised by the user. It is used to calculate exposure in a manual (non-automatic) mode. The formula is simple: Divide the guide number (GN) by the number of feet (F) from flash to subject, and the answer translates into an f-stop for use with a specific unit, film speed, and distance:

$$\frac{GN}{F} = f\text{-stop} \quad \text{or} \quad \frac{GN=80}{F=10} = f\text{-stop of } f/8$$

Fig. 5—1. Had the crew of this Oregon fishing boat been flash-photographed by guide number, the distance from flash to girls divided into the guide number would give you the f-stop.

That's all there is to it except the following:

 1. If you use a manual EF unit, or an automatic unit in manual mode, you had better make your own GN tests by shooting some slide film at precise distances from a human subject. Keep a record of *f*-stops for each shot, perhaps by asking the subject to hold a handmade *f*-stop card. Focus at ten feet for testing, for it's easy to convert your findings; multiply the *f*-stop used for the most satisfactory exposures by 10 to check or originate a personal guide number.

 2. Guide numbers given by manufacturers may be high (as a sales point), depending on the conditions under which they are determined. Tests made in medium-sized or small rooms with white or light-colored walls can influence guide numbers toward the high side.

3. When you shoot in relatively large, dark rooms or areas, or at night, guide numbers should be decreased by one-half to one stop. For instance, in a dark paneled den where reflective surfaces are inefficient, convert a guide number of 80 to 63 and 56, which becomes valuable exposure insurance.

4. Guide numbers do not apply directly when an EF unit is bounced or reflected toward the subject. A formula for this is given later.

If you have an auto-exposure unit, you may never have to refer to its guide number unless you use it in the manual mode — for flash-fill for instance — or want to compare the unit to others by GN standard.

DIRECT FLASH

WHO NEEDS CUBES?

While certain qualities of flashcubes and related lighting equipment are related to electronic flash, so few serious photographers use anything but EF that I choose to cover cubes quickly. Here is a comparison of cubes with electronic flash:

1. Flashcubes and other expendable light supplies can be more costly than using an EF unit unless you shoot only a few rolls of film per year.

2. Enough cubes to shoot several 36-exposure rolls of film take up more storage space than an average small EF unit.

3. Though you must renew batteries in an EF unit occasionally, you are more likely to run out of cubes than you are to run out of electrical energy for an EF unit.

4. Cubes flash at about 1/50 sec., which is often not fast enough to stop or freeze fast action, while the average small EF unit operates at about 1/1000 sec. which is a lot more fitting for subjects such as basketball games or children running.

Notwithstanding, if you like the idea of flashcubes or other expendable flash apparatus, use it and enjoy.

RECYCLING TIME

After an electronic flash is fired, it takes from a fraction of a second to ten seconds or more to *recycle*. During this period electricity from batteries or AC builds up power again in a main component of the unit. Newer EF units with a thyristor circuit to be described later may recycle in less than a second, while tiny units for 35 mm, 110-size and SX-70 cameras may take 9–12 seconds to recycle. (Here a flashbar or flipflash or cube is ready to use faster than a small EF unit, but potentially far more expensive.) In any case, ask about recycling time when you buy a unit, and remember when the time becomes uncomfortably long that you probably need either new batteries or the nicad batteries charged.

DIRECT EF PLACEMENT

In previous chapters I have alluded several times to the fact that identical placement of electronic flash and of flood-lights produces very similar effects so far as showing form is concerned. However, numerous photographic hobbyists restrict themselves to "formless" flash—i.e., one unit atop the camera. While I object to flash-on-camera in general, there are expedient reasons to use it, as Lynn McAfee did for her news coverage of actress Nichelle Nichols (Fig. 5—2), including these:

1. You're in a hurry, as news photographers are, and you want to be sure you light the subject adequately and freeze action as well. This sometimes applies to home or location snapshots, when you cannot take time for "fancier" lighting effects.

2. You want a certain stylized look, typified by some types of fashion photography seen today.

3. You want to emphasize the bizarre, outstandingly

exemplified by the work of Helmut Newton whose book *White Women* has a number of memorable direct flash shots in it. Influenced by Newton, I shot Fig. 5—3 with the help of a lovely model who enjoyed helping me with some synthetic storytelling situations. Look for unusual subjects where direct flash might be appropriate, and experiment for yourself, using the straight-on style for esthetic purposes.

Fig. 5—2. Lynn McAfee's use of flash-on-camera to photograph actress Nichelle Nichols is apt for news coverage, if not especially artistic.

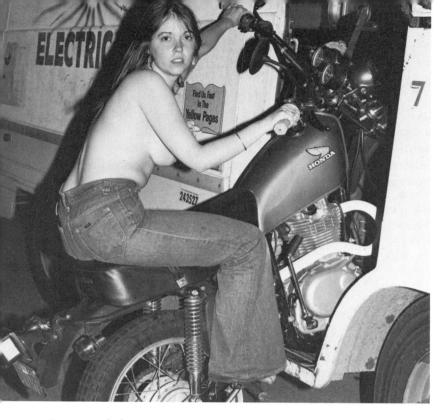

Fig. 5—3. Flash-on-camera may be used as an adjunct to the bizarre, humorous, or offbeat.

BOUNCED FLASH

One technique for alleviating the stark, primitive look of direct flash on the camera has been around a long time, and more people might take advantage of *bounced flash* now that manufacturers are making it more facile. "Bouncing" means to reflect your flash from a ceiling, and umbrella, or sometimes from a wall, onto the subject. Figure 3—21 is a typical example. Instead of having a black shadow behind the subject who must temporarily "go blind" from direct flash, softer bounced light creates shadows that show form better, and the light spreads more evenly over a group, even if members of it are not equidistant from the light.

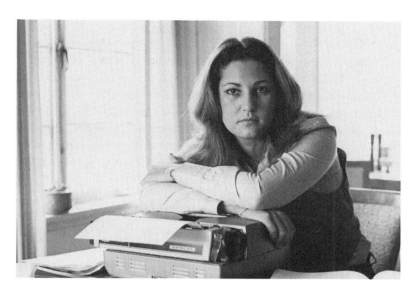

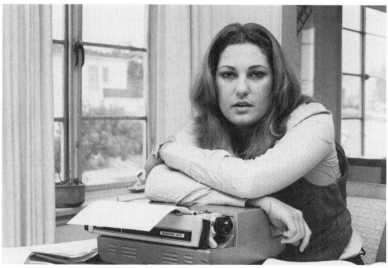

Figs. 5—4 and 5—5. Fig. 5—4 (top) was taken by existing light,
Fig. 5—5 (bottom) by bounced electronic flash. While the background
is clearer in Fig. 5—5, both portraits are acceptable.

I've been using bounced EF for a long time to shoot portraits of businessmen in their offices, for people at parties, and for simple snapshots indoors when conditions are right. By the latter, I mean when there's a light-colored or white ceiling from which to bounce or reflect the light. Dark ceilings are impractical for bounce, so be resigned to direct flash. In addition, when shooting color, bouncing light from brightly colored walls or ceilings may tend to tint your slides and prints, though it can be more easily corrected in the latter. If you must bounce against colored surfaces, warm-toned ones are preferable.

Figures 5—4 and 5—5 of screenwriter Pat Resnick taken for *American Youth* Magazine serve as an apt comparison of existing light and the bounced variety. (You should be familiar enough with direct flash-on-camera, to imagine how Pat would have looked if lighted that way.) Fig. 5—4 was taken at 1/125 sec. at *f*/8 on Tri-X rated at ASA 400*. I knew that the scene outside the windows would be overexposed, but I like the character of the light on Pat's face. Fig. 5—5 was taken as an alternative at 1/125 sec. at *f*/11 using a tilt-head automatic electronic flash on the camera, bounced off the ceiling. In it there's a little detail in the exterior scene, and the subject's face is more evenly lighted. Fig. 5—5 reproduces more easily in a magazine or book, because it avoids the burned-out white areas of Fig. 5—4. Variations on these bounced vs. existing-light effects can be simulated by readers in plenty of circumstances.

BOUNCE FLASH EXPOSURE
If you own a modern EF unit with a sensor that faces the subject when the light is pointed up or sideways, it provides automatic exposure capability, and you can skip this section. Otherwise, for general purposes, here's the formula for bounce-flash exposure in rooms with white or light-colored ceilings of normal height: Divide the guide number for a

*See chart, *ASA and DIN Film Speeds*, p. 189.

specific unit and film by 10. Then open the lens about 1½ stops. For instance, if your guide number is 110, divided by 10 you get f/11. Opening a further 1½ stops gives you f/6.3 as the aperture for bounced EF. However, you need to make your own careful bounce-flash tests to achieve exposure experience for yourself.

It is evident that bounced flash requires additional exposure because the intensity of the light is less than if it were aimed directly at a subject. Two useful things can be learned from this:

1. For more convenient bounced EF, choose a medium-fast or fast film in order to gain better depth of field via smaller f-stops permitted. If you were limited to an ASA 25* film and an average small electronic flash unit, you might have to shoot bounced flash at f/2, and your opportunities for image sharpness are decreased. Therefore, an ASA of 100* or faster is better suited to bounced EF.

2. Keep in mind that the smaller EF units are not very efficient for bounce flash because of their low light output. In addition, think carefully about buying an automatic unit that provides auto-exposure in the bounce-light mode via a sensor that faces the subject when the head is tilted.

3. Look again at the illustrations in Chapter 3 where an umbrella reflector was the main or fill light, because this is a desirable form of bounced illumination. When you use an umbrella or other reflector, you need not be dependent on a white ceiling, but you do lose between one and two stops of exposure.

Reflected and bounced electronic flash (or tungsten light) can be beautiful—don't neglect it!

MULTIPLE FLASH

As the Chapter 3 lighting exercises illustrated, two lights are often more versatile than one, and this holds true for flash also. Subjects closer to the camera are more brightly lighted

*See chart, *ASA and DIN Film Speeds*, p. 189.

by one direct flash at the camera than subjects in the background because of what is called the inverse-square law, explained simply like this: *Light falls off.* The farther a subject is from an artificial light source, the less light it gets, and the decrease is geometric, which means that a subject eight feet away from a light gets only one quarter as much light as a subject four feet away. For this reason you get dark backgrounds on single-flash shots. Switching to bounced flash can help, but using two or more flash units is another neat solution to know about.

Years ago several flash units had to be connected with wires that got in the way and took time to set up. One may still use a long cord to attach a remote flash unit to one at the camera for proper synchronization, but a small photoelectric sensor, often called a "slave eye," offers a lot more sensible method. A modern photo-eye sensor requires no batteries, and plugs into an appropriate socket of the remote flash unit. Point the sensor at the main light attached or wired to the camera by synch cord, and when the main light flashes, the second light is fired simultaneously. To try two units at once, either team up with a friend or borrow another unit before you invest in a second unit of your own.

FLASH PLACEMENT

Where you place the first, second, or third EF unit depends on the lighting emphasis you want, the subjects you're illuminating, and the character of the shadows in relation to forms. Familiarity with the placement of light sources as demonstrated in Chapter 3 is the best possible guide to multiple flash. From experience with floodlights, using EF comes more naturally.

Figures 5—6 and 5—7 compare single flash-on-camera with multiple flash. Fig. 5—6 lighting represents a popular approach discussed before, although the auto-exposure Vivitar 283 unit compensated nicely for light fall-off. A second small EF unit (an automatic Vivitar 215) was added for Fig. 5—7; it was mounted with a Vivitar photo-eye

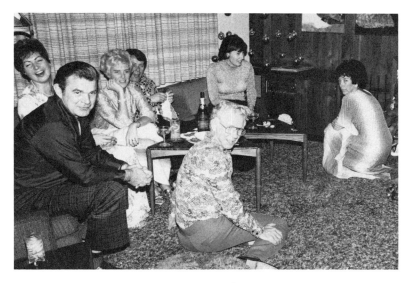

Figs. 5—6 and 5—7. One flash at the camera expediently caught friends at a party in Fig. 5—6 (top), but an additional flash off camera to the right produced a more interesting kind of light in Fig. 5—7.

attached to a light stand at the far right of the room. Normally, the larger flash on the camera would be stronger, but, as you see, the remote light is dominant, and the front light acts as a fill. The reason: The remote EF unit was pointed at an angle to strike the sensor of the on-camera unit, and thus it turned off sooner than if it had been measuring only light reflected from the subjects. However, the people are lighted in an interesting way to demonstrate how multiple flash creates variations according to distance from the subject, light output of the units, and exposure adjustments.

In general, people and things may be better lighted if the main light is closer to the subject or stronger, or both, compared to the secondary fill light. Therefore, place your flash units at distances and locations for appropriate modeling and light balance, according to the principles noted in Chapter 3. To imitate a professional technique, place a flood or quartz light next to each EF unit to predetermine the effects. These surrogate floods are called modeling or pilot lights, and are often built into studio-type EF units for convenience. To be really precise, light with a flood or quartz lamp, then move it away and replace it with an EF unit in the exact location.

MULTIPLE FLASH EXPOSURE

The best way to assure correct exposure with two or more EF units is by using guide numbers. Set your lens ƒ-stop for the nearer and/or stronger unit, knowing that the more distant or weaker one will illuminate the shadows made by the other. If you use two identical units, place one farther from the subject, and if that's not possible, reflect it from an umbrella or other surface. Test auto-exposure units in the automatic mode, and via guide numbers in manual mode as well to compare. Be careful how you aim the units, so that the sensors are not influenced by excessive spill light, as happened to me in Fig. 5—7. You might attach a small cardboard mask at one edge of the remote EF unit to direct

the light away from the main light's sensor. Incidentally, some automatic EF units have a variable-power setting, so you may dial one of your lights for less than full power as a means of varying the multiple flash effect.

Fig. 5—8 is an example of multiple flash where two units were reflected from umbrellas on either side of the camera, and a 500 W floodlight illuminated the background wall. At the left was a Larson Strobasol X8000 (shown in Fig. 5—14) aimed at a 36-inch Reflectasol umbrella from perhaps a 40-degree angle. At the right, close to and at the level of the camera, was a Vivitar 283 (seen in Fig. 5—12) on full manual power pointed into another umbrella. I used a Polaroid 180 camera (with conventional lens and shutter) to test the light balance, and an electronic flash meter to determine exposure. The picture was taken with a Bronica camera on Kodacolor II film in the subjects' living room, and can be simulated in an average home setting with suitable flash equipment. With a unit smaller than the X8000, place it a bit closer and shoot at an appropriate aperture based on your previous tests or Polaroid shots.

Fig. 5—8. Artful multiple flash included two units reflected from umbrellas at left and right, plus a 500 W floodlight on the wall behind the handsome group.

OTHER FLASH TECHNIQUES

These are mentioned briefly with a suggestion that you experiment, and read elsewhere for greater detail.

Painting with light. Set the camera on a tripod at night or in a darkened area. Open the shutter for a time exposure, and set an *f*-stop according to the EF unit guide number. Walk along the edge of the picture area and flash the EF unit in a slightly overlapping pattern as many times as it takes to cover a large expanse. This is called "painting with light," and is usually applied to architectural subjects where little or nothing moves in a broad area that would be impossible to light with a single flash or two.

Multiple exposures. There are several variations including the stroboscopic effects made by fast repetitive flash to produce 20 or 30 close-knit images of a subject, such as a golfer's swing, on one frame of film. Fast-firing units are available for specific applications. In addition, you can make multiple EF exposures for images such as the self-portrait in Fig. 5—9. I set the camera's shutter on "B" and kept it open

Fig. 5—9. This triple-exposure self-portrait was made using hand-held electronic flash, with the shutter open for a time exposure on a tripod-mounted camera.

with a locking cable release, after which I made three separate exposures at three locations. I guessed at using f/8 with Plus-X film, but the result would have been better at f/11 because of overlapping light areas. Bracket your exposures for such experiments because of effects you can't anticipate.

Bare-tube flash. A few EF units such as the Ascorlight Auto 1600 (Fig. 5—13) are manufactured with separate flash tubes and reflectors. By removing the reflector you have a bare tube, which scatters light in all directions, softly direct at a subject while also bouncing around the room. Bill Owens uses this technique successfully in his documentary books such as *Suburbia* and *Our Kind of People.* Bare-tube lighting is infrequent because the equipment is uncommon.

ELECTRONIC FLASH SPECIFICATIONS

Before surveying the equipment field, here are several basics for comparing EF units.

LIGHT OUTPUT RATINGS

The oldest rating system is by watt-seconds, which measures raw electrical power, and is not the best means of comparison, because the beam pattern of the reflector is not taken into account. However, professionals may use watt-second (WS) ratings for studio units designed with more uniformity than portable equipment.

A more reliable rating system is by BCPS, which stands for beam candlepower seconds. Guide numbers for EF units are often derived from BCPS ratings in Kodak film literature. Each doubling of a BCPS number indicates one stop difference in light output.

There is also the guide number for Kodachrome 25 mentioned earlier as a comparative standard for EF units. Be sure the guide numbers given for different brands are based

on the same film, for a manufacturer may use a faster film to gain a higher GN.

POWER SOURCES

Dry batteries. Most portable electronic flash units will operate on *alkaline batteries.* These are preferable to the carbon-type, which do not last as long. Some units may also be powered by *nicad batteries,* which sell for a lot more, but are rechargeable for many years. This means buying a charger, the newest of which will do the job in 15–30 minutes. However, nicad batteries can be temperamental; they lose their charge in prolonged (over 30 days) storage, and are most efficiently recharged only when fully exhausted. Therefore, stick with alkaline batteries unless you shoot often enough to make the nicad type more economical and practical.

High-voltage batteries. Special battery packs carried on a separate shoulder strap are made for some brands of EF units. These packs hold high-voltage batteries, which are expensive but provide a lot more flashes per set than any other sort of expendable source. An EF unit will also recycle faster for a longer period on high-voltage cells, but unless you shoot a lot of news-type pictures regularly, you don't need this kind of power supply.

AC power. All but the smallest portable units, and all large studio-type units can be powered by plugging them into a wall socket. You will need a long connecting cord to the camera, and if that does not restrict your movement, you enjoy constant inexhaustible energy for flash photography. Check the recycle time of various portable units on AC, for some are faster than others.

COLOR TEMPERATURE

All EF units produce light approximating the color tem-

perature of daylight, averaging 6000 K. Some units use warm-tinted reflectors or filters, but it seems likely that what you buy will produce acceptable color on daylight films. If this is not so, return the unit to the dealer, along with picture samples to back up your complaint.

ELECTRONIC FLASH EQUIPMENT

Because there are so many auto-exposure electronic flash units on the market at a wide spectrum of prices, non-automatic portable units will probably be phased out by the time you read this. If you find a non-automatic unit for sale at a very attractive price, buy it, use guide numbers for exposure, and pray a little.

Here is a shopping list of features to know about. The more of these you find in an EF unit, the higher the price is likely to be, the larger the unit, and the greater its versatility.

Variable sensor. An auto-exposure unit has a built-in (perhaps removable) sensor which reacts to light reflected from the subject nearest the lens, and *turns off the flash* at a time appropriate to the film speed and ƒ-stop dialed into the unit, to provide a "perfect" exposure. The least expensive EF unit may have only two sensor settings: "A" for automatic and "M" (or no initial) for manual. A dial tells you at what aperture to set the lens to match specific ASA speeds, but there is no choice of settings for various apertures.

An auto-exposure unit is regulated to turn itself off faster for fast films than for slow ones, and for wide apertures it turns off faster than for smaller ones. In addition, the closer the subject to the flash, the sooner the flash is turned off, or quenched. How all this happens in a tiny fraction of a second is a miracle of technology that I appreciate, but do not attempt to explain.

Larger and more expensive units may be programmed for a larger number of ƒ-stop settings, an advantage for efficient depth of field control. If your unit operates at ƒ/2.8

and $f/5.6$, it's not as handy as if it works at those settings plus $f/8$ and $f/11$. Therefore, choose a unit that offers all the f-stop options you can afford to pay for and carry.

Detachable sensor and swiveling flash head. The more sophisticated EF units include a detachable sensor, a swiveling head, or both. You swivel or tilt the flash head to point it at the ceiling in bounce position, while the unit itself is mounted in the accessory shoe of a camera. Though the head tilts, the sensor remains facing the subject, which is essential for accurate auto-exposure operation. Not having to guesstimate bounce exposures is a pleasure.

A detachable sensor may be mounted atop a camera to face the subject when the flash itself is placed on a separate light stand or held at arm's length. The remote sensor attaches to the unit via its own cord, and adds to the versatility of your lighting technique. Of course, you may connect any EF unit to the camera with a long synch cord, but unless the built-in sensor "sees" the light as the lens does, exposures will not be correct. Thus a remote unit without detachable sensor should be used in the manual mode.

Thyristor circuitry. When an ordinary auto-exposure EF unit turns off to provide proper exposure, the excess electrical power drawn from batteries for each flash is "dumped" or drained away harmlessly—and wastefully. In circumstances where the unit flashes at full power, such as for a distant subject, there is little or no waste, but when subjects are relatively close, only a portion of a full electrical charge is used, and the rest is dissipated.

To avoid this waste, the electronics industry devised thyristor circuitry, named for the component which allows the unit to retain the excess electrical energy not needed for each flash, rather than dumping it. Residual power is then

Fig. 5—10. Typical of swivel-head flash unit is the Sunpak 411 shown in three configurations for straight, bounce, and side directions.

Fig. 5—11. Flash head of the Kako Auto-2500 S tilts 90 degrees for convenient bounce illumination.

added immediately to the fresh energy charge that builds up during recycling time to accomplish these things:

1. It takes less time for a thyristor circuit to recycle, so when you shoot at fairly close distances, recycle time may be less than a second.

2. Less energy is drawn from batteries during recycle time, so they last longer than if there were no thyristor circuit at work.

Therefore, it's worth paying more for a thyristor-equipped unit in order to prolong battery life and to be able to shoot more quickly when necessary.

Variable power switch. This may be built in or may come as an add-on accessory to enable you to control the light output of an EF unit in manual mode. Variable non-automatic operation is useful for 1) flash-fill outdoors when the automatic mode is impractical. You may expose by guide number manually, but shooting at half-power, for instance, is an advantage as illustrated in the next chapter. 2) working close to a subject for which there may not be a precise automatic exposure *f*-stop/distance combination. Reducing a unit's light output provides for lens apertures that avoid overexposure.

Accessories. As you see in Fig. 5—12, an electronic flash unit may be accompanied by a whole system of accessories, including colored filters, variable-angle lenses, a high-voltage battery pack, pistol grip, bounce diffuser or reflector, and fitted camera brackets. You should buy only those items you really need or want to try for the fun of it. Consider the availability of accessories for a specific brand you may buy, however, whether or not you intend to take advantage of them.

There are automatic-exposure EF units for almost every type of camera including the SLR, pocket cameras, instant cameras, and medium-format models. Get as much

Fig. 5—12 (left). With the Vivitar 283 electronic flash, a full complement of accessories is available including bounce card bracket and high energy battery pack. Fig. 5—13 (right). Multiple exposure illustrates revolving head of Ascorlight Auto 1600 unit, popular with professional photographers.

versatility as you can for your money, and be happy that flash technology is so advanced.

AC-POWERED UNITS

Portable flash units include some as sophisticated as the Ascorlight Auto 1600 (Fig. 5—13) and the Norman 200, both battery/AC models, but larger units with greater light output operate only on AC power. Some elaborate equipment is available for professionals, with flash heads separate from powerpacks that roll around on casters.

For serious amateurs there are one-piece units with flash head and other electronics combined, such as the cleverly designed Larson Strobasol X8000 in Fig. 5—14. Other one-piece EF units are the Bowens Monolite X200 and X400, the Broncolor C70 and C171, the Elinchrom Unipak, the Hedler Rapid Blitz, Hershey Prolites, the Rollei E250, and several models from Multiblitz. Larger, more expensive AC-powered units offer these advantages:

—more light for use with color, for larger groups or areas, and for bounce, making smaller apertures practical,

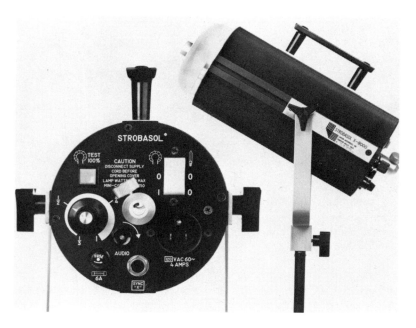

Fig. 5—14 (above). Portable, AC-powered, one-piece electronic flash unit for studio and location use is versatile and weighs only 7 pounds. Fig. 5—15 (right). Strobasol X8000 unit shown in Fig. 5—14 is here mounted for use with Larson Reflectasol umbrella, the shaft of which fits through center hole of flash unit.

—pilot lights built into many units for easier placement of the lights,

—accessories, such as barn doors or special reflectors, available to help control the light.

One-piece units are convenient to handle, and less expensive than most two-piece equipment, which is more powerful of course. For a home studio, a one-piece AC-powered unit plus a sophisticated battery-operated portable makes a good combination.

REFLECTING UMBRELLAS

Ask at your local camera shop about umbrellas, including the Larson Reflectasol line shown with the X8000 in Fig. 5—15. Larson also offers special clamps for umbrellas, and a diffuser called a Soff Box. The latter is on a frame that surrounds an EF unit such as the Calumet shown in Fig. 5—16. The lighting effect is similar to that of an umbrella, but light output from the Soff Box is slightly greater.

Fig. 5—16. Calumet electronic flash is surrounded by a Larson Soff Box diffusing unit which may be used instead of an umbrella.

Keep in mind that you can always reflect from a sheet of white cardboard. Devise a way to mount it in a stable position angled at your subject, using two light stands or a home-made frame.

EF LIGHTING KITS

Combinations of electronic flash units and accessories are available in kits packed into padded case by Elinchrom, Yashica, Spiratone, and other manufacturers. It should not be too difficult to create your own kit in a suitable case, perhaps with padding sculpted to fit your equipment.

Electronic flash comes in more shapes and sizes today than ever before, and is easier to enjoy for its direct, bounced, and off-camera lighting capabilities.

6

Outdoor Lighting

In the beginning, photographers had only daylight, and for decades this daylight had to be intense in order to make an image on the very slow film through a lens with maximum aperture such as $f/8$. Today we can shoot outdoors from the break of dawn to the last sliver of sunset in any weather. We also can take pictures after dark, covered in Chapter 8.

Pictures in color or black-and-white in many phases of daylight have been emphasized throughout this book, especially in Chapter 3 where directional lighting was related to the portrait exercises. Now, it might be asked, what's the problem in shooting in daylight? If there's enough light for a suitable exposure, what other involvements are there? Well, besides exposure, there's composition to think about, and sensitive photographers attempt to capture pictorial mood through lighting. In addition, we are dependent on light to help show form, texture, and relationships between people and things. With these goals in mind, let's talk about the characteristics of light as it changes throughout the day from sunrise until nightfall.

MORNING

The directional emphasis of sunlight in the first half hour or so after daybreak is dynamic. This helps give pictures a

111

Fig. 6—1. Exaggerated shadow evolved from early morning light combined with 15 mm fisheye lens effect at a high desert airport in California.

special atmosphere, and makes the early time of day a favorite of photographers. Shadows are long and visually forceful, as exemplified by Fig. 6—1 taken with a 15 mm fisheye lens perhaps 40 minutes after sunrise at a small California airport. One can enjoy photographing under the spell of the low-angled sun at sunset, too, as will be shown later, but sunrise is often a challenge to motivation, because it's not easy to awaken early sometimes. It may be cold and you may be tired from vacationing, but the early bird catches the slides and prints that win contests and are exhibited.

Dawn may also break in mist, when an overcast sky creates the kind of pastel color you can imagine at a Vermont farm in Fig. 6—2 taken by Roger H. Vogel to win a Kodak International Newspaper Snapshot Award (KINSA). The judges praised Vogel's atmospheric image for its

subdued color, which points up this moral: Don't be too disappointed when you rise early only to find the sun covered with clouds or fog. Look around and enjoy the softness of morning light that may be tinted or moody. (If it's mountains or sand dunes or cityscapes you're after, you'll just have to wait for shadows.)

AS THE LIGHT LIFTS

Obviously, the time of exciting light in the morning changes with the seasons, and with your geographic location. Readers in Alaska observe a different angle of sunlight at 9

Fig. 6 — 2. Soft, pastel light of dawn helped Roger H. Vogel win an award for his peaceful picture of a barn in Vermont.

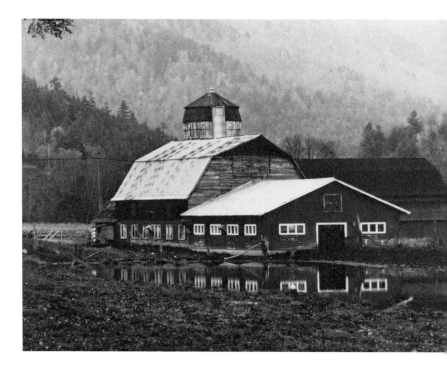

A.M. on a July morning than do those in Florida or Mexico. We know, however, that the sun peaks almost overhead in midsummer in most areas a few thousand miles north or south of the polar regions, and that it travels in an arc about midway above the horizon in midwinter. Wherever you may live, get to know the sun's positions in various seasons all the day long. When traveling, plot your movements to match an advantageous sun whenever it's feasible. For instance, Fig. 6—3 was taken in Arizona's Monument Valley by an American Airlines photographer at what looks to be a few hours after daybreak. There are form-making shadows to add drama, and it is likely the photographer planned this time of day to shoot.

In a more subtle situation, I watched the light change from a hotel window in Salzburg one morning, and shot several versions of Fig. 6—4 in October, before the sun illuminated my side of the street which contrasted with the

Fig. 6 — 3. Early morning was chosen by an American Airlines photographer as the time to shoot in Monument Valley for a travel article.

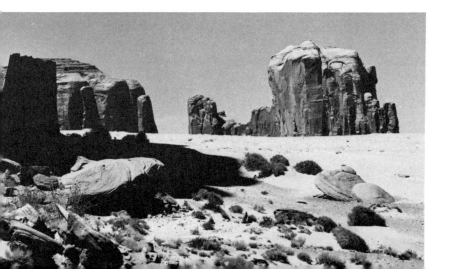

river. I photographed the same scene in color with another camera, but black-and-white has always had its own esthetic satisfaction for me.

HIGH NOON

Don't look for an illustration showing deeply shadowed faces and form-hidden objects lighted by the sun at high noon on a summer day, because the phenomenon is too familiar to include here. Eyes disappear in dark sockets, heads throw shadows on chests, and noses stand out as isolated highlights. Thus it is that photographers avoid the noonday sun whenever possible. Instead, while traveling, they tend to have a leisurely lunch or wander in a museum unless it's imperative to shoot because they're passing by in a rush. Around home, you should schedule picture-taking before 11 A.M. and after 2 P.M. in spring through fall, and you won't have a high-noon duel with the sun.

Fig. 6—4. Morning light contributes to the charm of Salzburg, Austria, as photographed from a hotel window with a 65–135 mm zoom lens on an SLR camera.

Figs. 6—5 and 6—6. Each of these was taken at 1/125 sec. at f/11 on Plus-X film. An electronic flash unit was used to fill the shadows for Fig. 6—6 (below).

116

FLASH-FILL

When sunlight creates awkward shadows on people, under some conditions you can brighten the shadows with electronic flash on the camera. The technique, called "flash-fill," is a little tricky, but worth knowing about in order to tame the sun's contrast, if you can't take your subject to a shady place. Here are the facts about flash-fill:

1. If you use a camera with between-the-lens leaf-type shutter, it synchronizes with EF at any speed, so you can enjoy flash-fill on a choice of films. However, a 35 mm focal plane shutter camera operates only at 1/60 sec., 1/90 sec., or 1/125 sec. with electronic flash, which can be a handicap. You can't stop down enough in bright sun with a fast film. You have to be careful dealing with fast action at 1/60 sec., for instance, because you'll get blur. But don't despair.

2. Use a slow or medium-speed film to make possible slow shutter speeds in bright sun. For instance, with Plus-X you may shoot at 1/125 sec. at f/16, and with Ektachrome 64 1/60 sec. at f/16 is feasible, but a 400-speed film is impossible, unless you use the neutral density filter discussed next.

3. A neutral density filter reduces effective film speed without altering color. ND filters are available in 2X and 4X densities. The latter cuts exposure four times, or two stops, making it possible to shoot about 1/60 sec. at f/11 with a medium-speed film.

4. Obviously, the main concern of the flash-fill technique is suitable balance between brightened shadows and existing highlights. Flash too bright will wash out, or overbalance, the sun. Over-fill is embarrassing and avoidable. The first of several methods to determine exposure for flash-fill is via guide numbers. With an auto-exposure EF unit in manual mode, mount it on the camera and set the shutter speed (remember the X-synch limit) and f-stop for correct exposure of a scene without flash. Then divide the

flash guide number for the film in use by the *f*-stop set. This will give you the flash-to-subject distance for *bright* fill—which you probably don't want. Here's an example:

$$\text{Guide number:} \frac{110}{11} = 10 \text{ feet for bright fill}$$

For less shadow illumination, move the flash back from the subject, or stay at ten feet and shoot at *f*/16, or diffuse the flash with a layer or two of white handkerchief. Make some experiments, or try another method.

5. The second method for flash-fill involves using an auto-exposure unit in automatic mode, following specific *f*-stop recommendations for various film speeds. As an example, suppose you adjust the EF unit for correct indoor exposure with the camera lens at *f*/11. To cut the light in half outdoors, adjust the flash mode for correct exposure at *f*/8, but *shoot at f/11*. Thus you "fool" the unit and regulate the flash for fill. To be thorough, test your unit in the automatic mode with backlight and sidelight, because it will be influenced by the intensity of sunlight on the subject and may turn off prematurely in some circumstances. Flash-fill

Fig. 6—7. At midafternoon the sun again slants pleasantly to make people and places look more appealing than at high noon. Extended shadows become part of the composition here.

will thus be insufficient. When you make tests, keep careful notes about ƒ-stops, distances, and auto-unit modes.

6. A third means of manipulating flash-and-sunlight exposure is by manually *varying the power* of the EF unit via a built-in or add-on dial. You must still stay with a specific maximum shutter speed, such as 1/60 sec., but by adjusting the EF unit to one-half- or one-quarter-power, you work with a revised, lower guide number. For instance, with a full-power guide number of 96 for an ASA 64* film, the GN becomes 68 at half-power and 48 at quarter-power. In this way, shooting fairly close to a subject, such as 3–4 feet, you can regulate the unit to 1/8 power or less.

7. In general, if you add light equivalent to between one-quarter and one-half of the sunlight falling on your subject, the effect will be pleasant, and not too obvious. Estimate guide numbers for certain distances when you choose an outdoor film to attain fill that is functional but doesn't look too noticeable or artificial.

AFTERNOON

As the sun descends, photographic light improves. A few hours after high noon—from late spring to early fall, and earlier in winter months—the sun's angle makes worthwhile shadows, such as those seen in Fig. 6–7. Faces are shadowed, but identities of my subjects were less important than catching the action. Bright sun is necessary for many action activities. You can use fast shutter speeds, even with slow films, but wait if you can for appropriate angles.

Midafternoon sun is interchangeable with midmorning sun for showing form in landscape, cityscape, and so on. Shapes within mountains begin to separate, rocks can be distinguished from each other, and buildings along a street assume stronger light and dark patterns. While others take siestas, you take pictures.

*See chart, *ASA and DIN Film Speeds*, p. 189.

Fig. 6—8. Sunlight streaming indoors can be controlled by turning the model, or by switching to another camera angle. Photo by Barbara Jacobs.

INDOOR SUN

Sunlight comes indoors from a window or door, making it very directional, and creating relatively strong contrast between highlight and shadows. Yet this type of light has its merits as seen in Fig. 6—8 by Barbara Jacobs. The model was pictured in her own living room by sunlight coming through a sliding glass door. Had the background been better illuminated, the left side of her body would have been more distinct, but this lighting is dramatic and serves a useful purpose to reveal and disguise simultaneously.

Consider mixing sunlight indoors with floodlight or flash-fill, perhaps reflected from an umbrella or nearby wall. In color especially, brighter shadows help define details, and the effect can be rather warm when you use floodlights with a daylight film.

OPEN SHADE

Indoors near a large window or door where diffused daylight is strong enough, and outdoors anywhere that there's open shade, photography—especially of people—can be a delight. Under a tree or on a porch in *covered* shade, the light may not be intense enough for comfortable shutter speeds and/or *f*-stops. However, in places with minimum interference between subject and sky light, with no direct sun, portrait results are usually lovely. Figures 6—9 and 6—10 illustrate this, my favorite kind of natural light, when people don't have to squint or be uncomfortable, and a photograph shows people more softly without strong lighting contrast. In many ways, open shade offers qualities similar to reflected light from an umbrella. Sometimes you can find locations where ambient reflections from a wall, for instance, give even more pictorial interest to open shade.

Fig. 6—9 was taken on a shady patio as part of a 36-shot series using a motorized SLR to capture many

expressions and poses in close sequence. The time was midafternoon. Fig. 6—10 was taken under the shade of a small tree, also in midafternoon, with Plus-X film at f/8 and 1/60 sec. A faster film would have been preferable, because there were some pictures on the roll that suffered from camera movement. Next time I will shoot at 1/125 sec. for insurance.

Fig. 6—11 typifies the emergency of mood in open shade where a low light level fits the model and setting. This is one of many instances where light *motivates* or *inspires* picture-taking. I had been shooting in brighter open shade, and decided the white furniture against the dark background had pictorial impact. Had Fig. 6—11 been taken in sunlight, it would have been mundane and not worth saving.

LATE AFTERNOON

The several hours before sunset are favored by more aware photographers than any other time of day. Slanting light resembles that of morning, but in many places there's less likelihood of fog or overcast in the afternoon, and it's a time not requiring early rising. As the sun gets closer to setting, it may shine through haze near the horizon, and the light is warmly tinted to create lovely pictorial effects.

Before sunset, backlight may be easier to work with, as noted in Fig. 6—12, because strong contrast seems consistent to the angle of the sun. I knew the bright outline of the mountain goat would be overexposed, but since film is not made to hold detail in such circumstances, you try to exploit a striking effect. At high noon or with front light the same picture situation would have been much less interesting.

In times past, traditional photographers were told to avoid the golden light before sunset, or to correct it with filters. Fortunately, what was once thought of as a "distortion," when seen literally on slides or prints, is now sought after by amateurs and professionals alike.

AT SUNSET

If there is one state of the light that needs no introduction or emphasis, it's the time before and during sunset. When you come to a scene such as Fig. 6—13 in the Sierra foothills of California, you need no urging to take pictures. Primarily, you want to assure good exposures (plus something of interest in the foreground), and the answer is bracketing. Shoot at the setting your meter indicates, after which shoot a half or a full stop on each side of the meter setting. You're trying for good color saturation or an optimum exposure in black-and-white that avoids excess negative density.

At sunset the light is beautiful, and can enhance almost any scene, including the foreground. Keep in mind that because sunsets are such popular subjects, you should try for a special flair of composition, color, or content to compete best in contests or impress viewers anywhere.

MISCELLANY

Outdoor lighting is hardly a mystery, but it can be challenging. It comes from all directions, and of course you should ignore the antique advice about shooting "with the sun over your shoulder" because it's a static formula. The direction and contrast quality of light is often simply there, and you can't do much about it but wait, or return. In general, when you have a good feeling about a subject, its shape, texture, reflectivity, or translucence, the light is right.

And, finally, there's outdoor light during rain and snow when we are often discouraged from taking pictures. Instead, take some chances for fun and experiment. Protect your camera in a plastic bag, and yourself in whatever you wear in such weather, and respond to the cold light of rain and storm. The sky turns blue-gray, the streets shine with colored lights, and in snow there may be gloom or cheer, but always the light will be different than you've photographed in before.

Fig. 6—9. A shady patio provided soft light where the model was at ease and not disturbed by glaring sunlight.

Fig. 6—10. A tree diffused the light on actress Pamela Scott Hall, who didn't have to squint as she might have in bright sun.

Fig. 6—11. The white props suggested use of a low light level and dark background for maximum pictorial impact. An SLR camera fitted with 50 mm lens was used.

Fig. 6—12. Backlighting outlines the mountain goat dramatically, giving a sense of color to this black-and-white scene taken with an 80–200 mm zoom lens.

Fig. 6 — 13. Sunsets are among the most popular subjects with photographers everywhere; they require skillful exposure and appealing foregrounds.

Which reminds me of the description of an Alaskan "whiteout," where the land is covered with snow and ice, and a cloud layer of uniform thickness covers the sky. As the rays of the sun pass through the clouds, they are diffused, and strike the snow from many angles. Diffused light is then reflected back to the base of the clouds, and back again to the snow cover. The process is continuous and all shadows are destroyed until neither clouds nor horizon can be seen and the sense of depth is lost. A whiteout is a great hazard to pilots, and sounds like the ultimate of bounced light for photographers!

The energetic photographer shoots when others seek shelter, and has patience to wait for changes of light as well. He or she knows that photo opportunities wait for no one.